Collins

Drawing &
Sketching

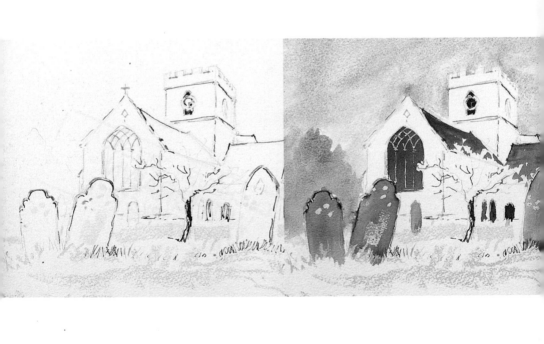

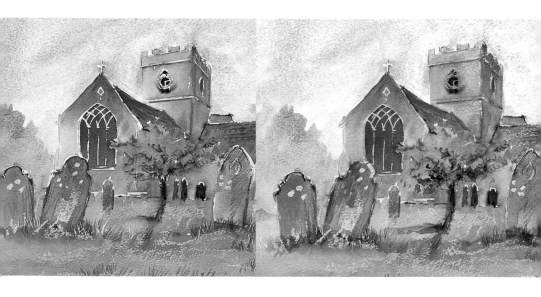

Collins need to know?

Drawing & Sketching

All the equipment, techniques and
inspiration to start drawing and sketching

Jackie Simmonds ● Wendy Jelbert ● Marie Blake

First published in 2005 by
Collins, an imprint of
HarperCollins*Publishers*
77-85 Fulham Palace Road
Hammersmith, London W6 8JB

The Collins website address is:
www.collins.co.uk

09 08 07 06
6 5 4 3 2

A catalogue record for this book is available from the British Library

Created by: SP Creative Design
Editor: Heather Thomas
Designer: Rolando Ugolini
Cover design: Cook Design
Series design: Rolando Ugolini

ISBN-13 978 0 00 719327 1
ISBN-10 0 00 719327 0

Originally published by Collins as:
You Can Paint Mixed Media, 2002
You Can Paint Pastels, 2000
You Can Paint Sketch, 2001

Colour reproduction by Colourscan, Singapore
Printed and bound by Printing Express Ltd, Hong Kong

contents

The authors

Jackie Simmonds

Jackie Simmonds began to paint in her thirties, attending art school as a full-time 'mature student', and she is now a busy painter and art instruction author. Her work is exhibited regularly in both mixed exhibitions and one-woman shows, and reproductions of her work have been distributed world-wide. Jackie writes regular articles for *The Artist* magazine, runs workshops and painting holidays, and has written five art instruction books and made six painting videos.

Wendy Jelbert

Wendy Jelbert has painted from an early age, and her three children as well as grandchildren do the same! She attended art school, studying fine and abstract art, pottery and print-making. She exhibits at the Century Gallery in Hartley Wintney, Hampshire, First Floor Gallery in Romsey, Hampshire, Burford Gallery in Burford, Oxfordshire, and Wykenham Gallery in Stockbridge, Hampshire. She runs workshops and has made five art instruction videos and written 14 books.

Marie Blake

Marie Blake trained as a painter at Kingston-upon-Thames School of Art and later qualified as a teacher of art at Central College, London University. She has taught art at both primary and secondary level and also has extensive experience of teaching leisure painters. Marie exhibits her own paintings and she is a regular contributor to *Leisure Painter* magazine. Her first book *You Can Paint Pastels* was published by HarperCollins Publishers.

Introduction

As a child, you probably revelled in the business of making marks. Even tiny tots love to grab a pencil or crayon and will scribble away with intense pleasure for ages. Of course, children are completely uninhibited and, in their innocence, will be delighted with the results they achieve, whatever these look like. As adults, our inhibitions grow, and we often feel embarrassed if we produce less than perfect results, particularly when we are encouraged to show our efforts to others. This book will encourage you to have a go at drawing and sketching, regardless of any lack of experience, in order to rediscover the sheer joy to be gained from them.

Learning to sketch is great fun, and although the word 'learning' implies a duty, it is important to remember that learning can be very exciting, challenging and, most importantly, rewarding. Your confidence will grow, and tentative beginnings will soon develop into positive results. Best of all, you don't need to be an expert draughtsperson to enjoy

sketching – absolute accuracy is not essential in most sketches, and often it is the unfinished quality of a sketch that adds to its appeal.

When you make a sketch, you are not necessarily producing a work that will find its way onto the walls of an art gallery. Sketches can be made for a variety of reasons: to collect information, to explore

▼ You don't have to use a pencil, pen or charcoal for sketching. These sheep were sketched with watersoluble art pens.

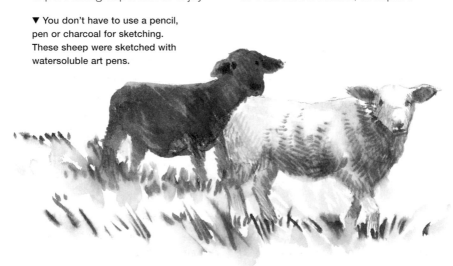

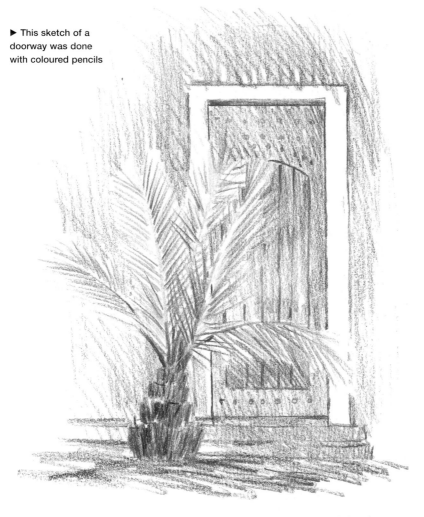

▶ This sketch of a doorway was done with coloured pencils

possible subjects for later pictures, or even just for fun. What matters is that with every sketch you make, you learn something about drawing and also improve your eye/hand co-ordination skills and powers of observation. This will help you to establish a firm foundation from which you will be able to grow as a creative individual.

Look upon this book as a valuable source of help and information, while you practise and develop your sketching language. You can keep your sketchbooks totally private – they should be, after all, working exercise books. Nurture your budding talent gently, and only when you feel ready do you need to show others the results of your efforts. That may be sooner than you think, provided you get stuck in with a positive attitude and practise, practise, practise!

How to use this book

This is an art instruction book for beginners, containing a large variety of examples, exercises and demonstrations. However, what it does not contain is reams of text. Although some written, or verbal, explanation is obviously very useful, there is still nothing quite like the physical act of making a sketch yourself, or watching a teacher.

Every page of this book offers you an example of a sketch, and each exercise is simply and clearly explained, and broken down into simple steps which are easy for you to follow. By all means, copy the examples given, but once you have tried out an exercise, and you have become familiar with the techniques explained, the best course of action is to find a similar object, or subject, and then to work from life, using the basic principles and techniques that you have been shown.

You will notice that we have not always been specific about the 'names' of the colours that have been used. This is because there are many different manufacturers of art materials on the market, and each manufacturer uses slightly different names. Don't worry about this; simply use a similar colour to the one shown; that will be fine.

The exercises and examples are generally relatively short and quite straightforward. However, in some of the chapters, you will find a slightly longer demonstration piece, which is broken down into several more steps for you to follow.

Throughout the book, a variety of sketching tools has been used to

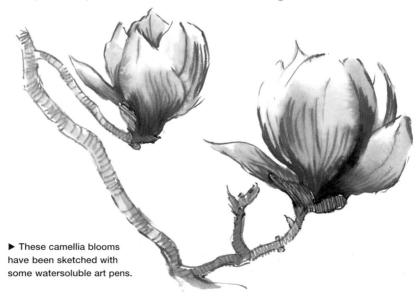

▶ These camellia blooms have been sketched with some watersoluble art pens.

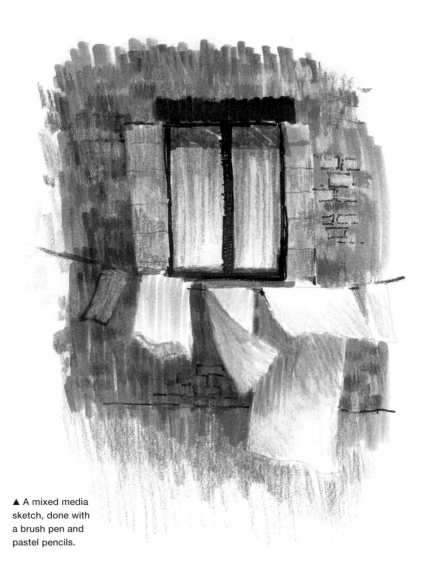

▲ A mixed media
sketch, done with
a brush pen and
pastel pencils.

enable you to become familiar with
different materials, including lead
pencils, coloured and conté pencils,
watersoluble coloured pencils, art
brush pens, charcoal, pastels, inks
and even watercolour. You may
like some materials, and some
subjects, better than others; it is
important to discover what you like

to draw and the materials you enjoy
using. Keep an open mind, and be
prepared to try everything.

As you practise, your own style
will gradually emerge. Always work
in a sketchbook, and by the time
you have filled it, you will find that
your drawing fluency and skills will
have improved immeasurably.

materials &

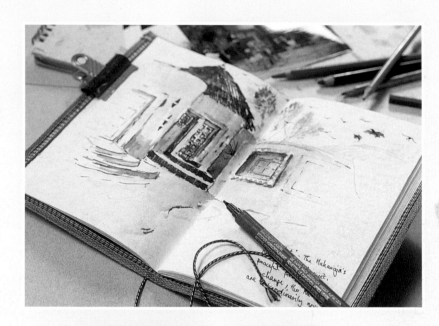

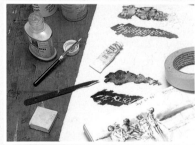

techniques

You cannot start sketching and drawing without learning about your materials, and the kinds of marks you can make with them. It is essential to practise and have fun while you do so. Enjoy every moment, throw yourself into learning with enthusiasm and an open mind, and you will soon be on your way to producing great drawings and sketches.

Basic materials

You will find all sorts of different drawing media in your art materials shop, and although no one drawing medium is superior to any other, some are more popular than others, especially lead pencils, charcoal and conté sticks, which have proved their versatility over the years. It is only by trial and error – or perhaps trial and success – that you will discover which medium suits you best.

A range of drawing and sketching materials are used throughout this book, some of which are traditional whereas others are more modern. There are many innovative materials now available, such as watersoluble pencils and art brush pens, which have a firm point at one end, just like a fibre-tip pen, and a softer, brush-like tip at the other end.

In addition, you can have fun experimenting with pastels, conté, coloured inks, watercolours and other media. The selection is varied enough for you to enjoy discovering a fascinating range of drawing and sketching possibilities.

▼ Sketching materials can be simple and very lightweight. For the basics, all you need is a sketchbook and some pencils.

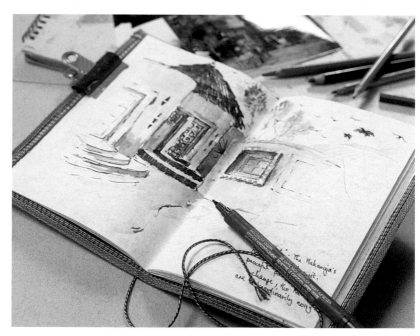

Suggested materials

Some popular drawing materials are:

- **Lead pencils** Start with grades HB (medium hard), 2B (soft) and 4B (very soft). Always buy good-quality (more expensive) pencils, since the better-quality pencils have the lead bonded to the wooden case to prevent the lead breaking if you drop them. It is most frustrating to try to sharpen a pencil only to discover that the lead is broken all the way to the bottom. Ask for advice at your local art materials shop if you are not sure which manufacturer's products to choose.
- **Charcoal sticks** These are available in various sizes. It is probably best to buy a mixed box.
- **Compressed charcoal in pencil form** This is useful for more detailed work.
- **Conté** This is available as both sticks and pencils.
- **Pastel pencils** These are thin sticks of hard pastel in pencil form.
- **Coloured pencils** These are clean and portable.
- **Watersoluble coloured pencils** The marks can be dissolved to give a watercolour wash effect.
- **Art brush pens** These are pens with a fine tip at one end and a brush at the other.

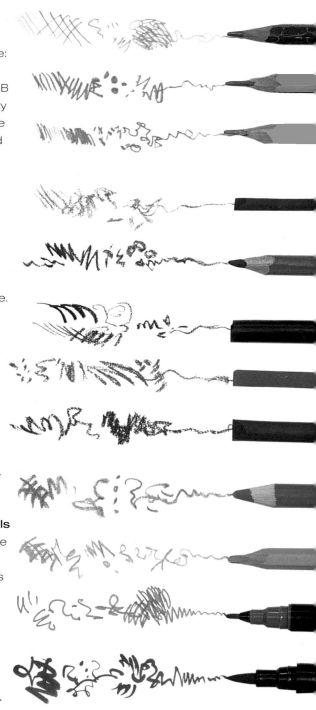

▶ Here are some of the sketching implements used in this book, as listed above, together with the marks they make.

Other materials

In addition to the basic materials already mentioned, you may want to expand your range and try other media, such as those listed below.

Pastels

You will need traditional pastels and oil pastels. You can buy a 'cheap and cheerful' set of 2.5 cm (1 in) long soft pastels. Round pastels create soft effects whereas the square, firmer ones are good for fine details. Your set of oil pastels should contain the 'fatter' varieties as these are better at resisting watercolour (they repel watercolour paint and let the pastel colour show through) than the harder, smaller varieties. These may also be bought separately. Include some lighter colours, such as pale cream, greys, greens, pinks and white.

Drawing pens

These include felt-tips and fibre-tips which can be bought separately or in sets. The 'throw-away' drawing pens with steel nibs are excellent, especially a black and sepia size 01 and 02 in both waterproof and watersoluble ink. There is also an excellent pen for sketching that requires cartridges; it is rather more expensive but well worth the extra. Again, use both black and sepia.

Coloured inks

It's a good idea to purchase a set of coloured inks in pots: choose your favourite colours to try out. They can be applied with a dipper, a ruling/drawing pen or a brush.

▼ Watercolours are a great medium for making sketches. All you need is different coloured paints in tubes and pans, some brushes and special watercolour paper.

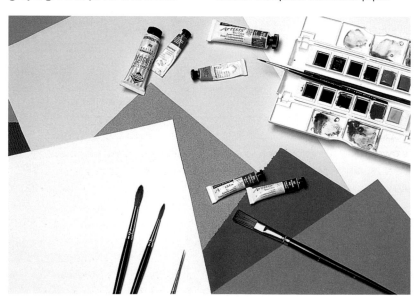

Some watercolour paints are very transparent; others are more opaque. Note down in your sketchbook the properties of various colours; they can affect the quality of your washes.

Watercolours

Two qualities of watercolour paints are available: Students' and Artists'. They come in both pans and tubes. We suggest that you buy a pan set of watercolours in Artists' quality. You can always add some more colours later on as you need them.

Just before you start work, always wet over the dry surface of your pans to prime them ready for painting. You will need to include the primary colours – red, blue and yellow – from which all the other colours can be mixed. We suggest that you also buy Yellow Ochre, Burnt Sienna, Cerulean Blue and a ready mixed green (Hooker's or Olive) plus a dark brown.

White gouache

This thick 'covering' white paint is supplied in tubes; it may be used on its own or mixed with watercolours. It is also useful for when making alterations and correcting mistakes.

Brushes

Although sable brushes are the best you can buy, the synthetic ones or sable/synthetic mix are ideal. You will need a selection of brushes: a no. 5 and no. 10 round-headed, a no. 12 flat-headed and also a rigger no. 1. Remember, the higher the number, the larger the brush.

You will also need

- **An eraser** A putty eraser is best for charcoal, and a firmer, plastic eraser for pencil.
- **A craft knife** This is useful for sharpening your pencils.
- **Fixative** This is a spray used to prevent drawings from smudging.
- **Masking fluid** This is good when working with watercolour for blotting out areas you don't want to paint. You also need an applicator.
- **A plastic palette** This is useful for preparing watercolour washes.
- **Bulldog clips** These are useful out of doors in windy weather, to keep your sketchbook open.
- **A sturdy pencil case** Or use a hinged, metal spectacles case.
- **Drawing board** This is useful to secure your paper to. Masking tape could be used for this purpose.
- **A torchon** A rolled paper stump, for blending charcoal or conté.
- **A fine sandpaper block** This is used to create a sharp point on a pencil or a piece of charcoal.
- **A sketching easel** This is useful if you prefer not to work with your sketchbook on your knee.
- **A lightweight sketching stool** This is very useful out of doors.
- **A long stick for measuring** A smallish plant stake is ideal.
- **A bag** For all your equipment.

MATERIALS AND TECHNIQUES

Sketchbooks

The variety of sketchbooks on the market can be bewildering. However, it's a good idea to have a selection of sketchbooks of different sizes, which range from pocket-size to large. Also, it's interesting to try different surfaces. You will quickly discover that sketches on cartridge paper, which is quite smooth, look very different from sketches on watercolour paper, which is often textured. A sketchbook with coloured paper pages makes an interesting and challenging change from white paper.

Make sure that your sketchbooks have good, solid covers which will stand up to normal wear and tear. Also, if you plan to use watersoluble implements, it is sensible to use heavier papers – either a thick cartridge paper or a watercolour paper (see opposite) – since thin, lightweight papers will buckle when you add some water. A spiral bound sketchbook can be useful; if you like to work on one page, you can turn the rest back. If the book has a firm binding, do not be afraid to work across the centre if you want to create a large drawing.

▼ You may need a selection of different sketchbooks, as illustrated here.

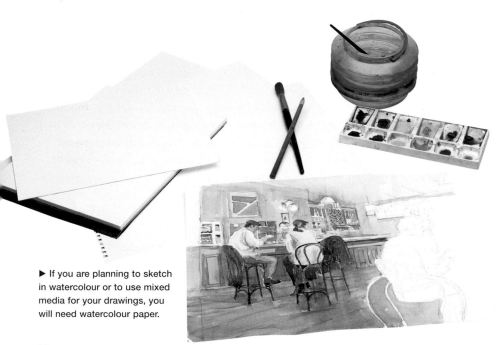

► If you are planning to sketch in watercolour or to use mixed media for your drawings, you will need watercolour paper.

Paper

The specially made-watercolour papers are best for sketching in watercolour and mixed media. Their surface texture holds the liquid colour and helps to create a unique watercolour effect. You can use either Rough, Not or Hot Pressed paper, but the Not surface is the one that is most commonly used by beginners. Paper weights vary but a 300 gsm (140 lb) watercolour paper, which is available in sheets, spiral-bound pads or blocks, is ideal when you are starting out in watercolour sketching. If there is little watercolour used in your work, you can get away with a 190 gsm (90 lb) Not surface paper or pad.

You may also have fun working with coloured papers. Heavyweight mountboards, scrapbook paper or assorted coloured paper pads for the brighter colours are ideal. Some pastel papers would also be fine. These have a textured surface to hold the pastel particles and are available in a large range of colours. White paper can be used for studies, but mid-toned coloured papers are easiest for painting. A useful size is 305 x 229 mm (12 x 9 in).

MUST KNOW

Using spray fixative

If your sketchbook does not contain tissue interleaves between pages, when working with pastel pencils, conté, charcoal or chalk pastel, give a finished sketch a burst of spray fixative to prevent it transferring to the opposite page.

Making marks

One of the best ways to learn about your materials is to analyze what they can do by making marks. Start off by producing some practice sheets, beginning with that most familiar of objects, the lead pencil. Don't expect your results to be identical to the ones that are illustrated here; everyone has their own personal handwriting.

Graphite lead pencils

Lead pencils are graded – those with an 'H' designation are harder than those with a 'B' – and thus 2B is soft, 6B even softer; 2H is hard and 6H is very hard. The softer the pencil, the blacker the mark it makes. Try using some HB, 2B and 4B pencils and study the different effects.

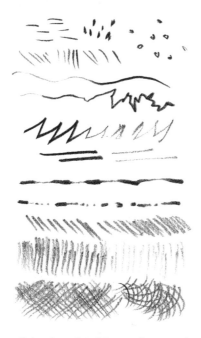

▲ To create an area of interesting texture, scribble with the point of a pencil, then use an eraser to soften lines and remove areas.

▲ Using the point of the pencil, try creating lots of lines. Vary the pressure on your pencil, and make sure you always keep the point long and sharp. Develop some parallel lines into areas of shading, to create 'tone'. Then criss-cross some lines in different directions; this is called 'cross-hatching'.

▲ Sharpen the pencil to a long point, and create an area of 'tone' by using it on its side. Hold the pencil cupped in the palm of your hand, with your fingers pointing downwards and the back of your hand facing upwards. Add more graphite to the base of the shape as you work.

Charcoal

Charcoal is wonderfully versatile, and easy to correct, so it is the perfect sketching medium for the beginner. In stick form, it is particularly good used in a loose, sketchy way which doesn't involve too much detail, and compressed charcoal sticks can be sharpened for detailed work. Charcoal work needs a spray of fixative to stop it from smudging.

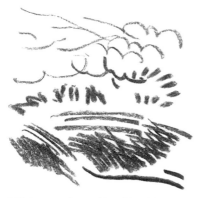

▲ Make some lines with a thin stick of charcoal, and then try some cross-hatching, too. If you turn the stick in your fingers as you work, you can maintain a point. Then try this again with a charcoal pencil, just to see how different it feels.

▲ Use the side of a stick pressed against the paper to cover an area of paper – you will find that thicker sticks are easier to hold. Try using different types of paper to see the effects – watercolour paper breaks up the marks far more than smooth paper.

▲ Scribble some lines with the point of the charcoal, and then blend, or smudge, them with a finger. This is a useful technique to master for creating lovely soft effects, with no hard edges or texture.

▲ Use charcoal on its side for a dense area of tone, and then lift out light areas with a piece of putty eraser. If you squeeze the putty eraser into a point, you can also lift out fine lines.

Conté

Conté, either in stick or pencil form, behaves much like charcoal, but it is harder. Nevertheless, it is still possible to blend colours by rubbing with a finger, or a rolled paper stump (called a 'torchon'). Conté is less 'sooty' than charcoal, and colours can be mixed by laying one colour over another. Conté comes in a variety of colours; try experimenting with the traditional black, white and earth colours – sepia (dark brown), sanguine (terracotta) and bistre (brown). In stick form, it can be sharpened to a point, or used on its side for blocking-in larger areas.

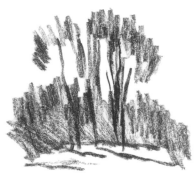

▲ Use one of the brown earth tones, together with a black conté stick or pencil, to try out linear marks. Work freely and swiftly.

▲ Now try sanguine, which is a lovely warm red. Vary the pressure as you work – your marks will be darker where you press harder.

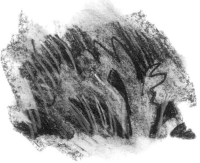

▲ Break a small piece from a stick of conté, and use it on its side, twisting your wrist as you work. The texture that you achieve will depend on the paper you are using, so it may differ from the one shown above.

▲ Use the conté on its side, then smudge with a finger. Scribble on top with a darker tone, and then try some white lines over the top. If you 'fix' it before using white, the lines may be clearer.

Pastel pencils

Pastel pencils are essentially thin sticks of hard pastel in pencil form. Unlike ordinary sticks of pastel, the pencils are clean to use, and they will not break or crumble. They are excellent for colour sketches but will need a spray of fixative to prevent them from smudging. You can use them in white sketchbooks, but it's also fun to try them on coloured paper, so that you can use a white pencil as well as coloured ones.

▲ Using colours of your own choice, make a variety of lines, dots, and stabbing marks, being conscious of the pressure you use and the effect you produce as a result.

▲ Now lay lines over each other to create a denser, more textured effect. Build up the area gradually, leaving some paper showing between the strokes.

▲ Using three different colours, make three strips of lines, and then blend lightly with a finger. Blending will create a soft, diffused effect, much like a watercolour 'wash'.

▲ Blend two or three different blues together, and then make some lines over the top. Finally, finish off with white and blue dots, or any marks which appeal to you.

Pastels

You can be really inventive with a stick of pastel in your hand. The most important thing to realize is that the stick has a tip, but it also has a side surface, and you can, and should, use both. Also, you need to practise varying the pressure of your marks, since the kind of mark you make will vary dramatically, depending on the pressure that you use.

▲ Make a light stroke (left); break the pastel and use its sharp edge for a thin line (centre); drag a wide band with its full length (right).

▲ Repeat the process, but this time using increased pressure on the pastel. Notice the different effects that can be created.

▲ Working horizontally across the paper, graduate each stroke, progressing from heavy to light. Observe the different effect.

▲ Apply diagonal stripes: 'close-hatching' or 'infill'.

▲ Repeat and blend by rubbing gently with tissue.

▲ Repeat and blend this time with a finger.

▲ Make diagonal spaced blue lines ('hatching').

▲ 'Crosshatch' in a counter direction with yellow.

▲ Finger blend the yellow into the blue.

▲ Drag a band of blue next to a band of yellow, and then finger blend the two bands together.

▲ Drag a blue horizontal band, then cross it with a vertical yellow band. Notice the colour blend.

▲ Repeat, but spray with some fixative before you apply the yellow. Notice the colour separation.

▲ Heavily infill in blue, then finger blend gently, obscuring the individual strokes.

▲ Transfer the colour which is left on your finger to make a fingerprint texture.

▲ Alternatively, rub the colour into the paper to give a diffused texture.

▲ Make blunt stipple marks with a short length of blue pastel; overlay with yellow.

▲ Make some sharp stipple marks in blue, and then repeat in yellow.

▲ Gently flick feathering strokes in blue, followed by some in yellow.

Traditional pastels on coloured paper

Coloured paper offers an exciting surface for pastels. You will need three different coloured pastels for these examples.

a) Gently apply feathering strokes in one colour and smudge it, follow it with a second colour and smudge this, leaving some areas untouched, and add some strokes of the third colour.

b) Wiggle a series of colours overlapping each other. Build up the area, leaving some paper showing between the shapes.

c) With definite sideways strokes apply a series of contrasting thick and thin hard-edged markings.

Oil pastels

These pastels will feel different from traditional pastels, but initially their markings are similar. The examples below are worked up using some coloured paper and three different coloured pastels.

a) Combine coloured blended areas over and under feathering strokes.

b) Make lines and dots using different parts of the pastel.

c) Scribble areas of different colours and then gently blend some of the colour together creating an effect similar to a watercolour wash.

d) Use different pressures to create a graded effect.

e) Try out sweeping movements with curling strokes, applying different pressures.

f) Cross-hatch one colour over another, and blend some of the pattern with a finger.

Coloured wax pencils

Coloured wax pencils will probably feel quite familiar to you – we all used them as children. They are clean and portable, and available in a wide range of colours. They allow you to create areas of delicate colour as well as fine detail. Always sharpen your pencils to a long point, and as you work, practise rotating the pencil in your fingers to keep the point nice and sharp. Rather than pressing hard to achieve dense layers of colour, which can make the surface slick and greasy, it is generally better to build up layers gently, allowing the white paper to 'illuminate' the layers.

▲ Using one pencil, build up the colour gradually, with a series of layers, thereby creating an area of tone.

▲ Try two different colours, and see how they create the illusion of a third colour where they mix together.

▲ Now try two or three colours from the same 'family' of colours: oranges, perhaps. Leave gaps of white paper to add sparkle. Areas of colour created by using several similar colours have a lively, exciting feel.

▲ Sharpen a pencil to a long point and, holding the pencil at its far end, scribble down an area of colour – the purple was used first here. Then try adding fine detail in lots of colours over the top.

Watersoluble coloured pencils

These are a wonderful modern medium, which extend the versatility of coloured pencils dramatically. Marks can be dissolved with a brush, sponge, or even a wet finger, to create fascinating watercolour-wash effects. Then, when the paper is dry again, you can add more marks and areas of colour. It is best to use watercolour paper, or heavy cartridge paper. Do not dip the pencil into water: dampen the tip with the end of a wet brush for softer marks.

▲ Make simple lines, and then dissolve them into a puddle of water.

▲ Shade two colours together. Dissolve with water to see how a third colour is created.

▲ Scribble an area of colour. On the left-hand side, drop down a very wet puddle; on the right-hand side, use an almost dry brush to loosen the colour. See how they differ.

▲ Wet the paper first, and while it is runny-wet, make some marks and see how they soften and dissolve slightly.

▲ Make some lines, and then dab them with a wetted sponge. Also, you can try scribbling directly onto the sponge with the long point of a pencil, and then you can make textural marks with your sponge – this technique is great for foliage.

▲ Wet the paper, and drop tiny pencil shavings cut with your craft knife down into the wet area. Firmer shavings will look like little curls of colour. These 'bricks' were drawn with a pencil, wetted, then colour was shaved into them for a textured effect.

▲ Dampen a pencil with water and twist so that the pigment is applied both wet and dry onto the paper.

▲ Draw simple lines of colour, trying out one, two and three colour cross-hatching. Partly wet these, using a brush, then carry the wash onto the paper.

▲ Wet some of the paper then pat the end of a brush over a wetted pencil to splatter the colours. Note the different effect in the wet and dry areas.

▲ Wet the paper surface and scrape in splinterings with a knife, then wash over. Repeat to intensify the tone.

▲ Dampen a pencil with water and apply a doodle to the paper. Wash over it; the pencil becomes indelible.

▲ Build up the colour gradually using a series of feathered layers. Use a brush to wash over half.

▲ The darkest mark that can be obtained from a pencil is by placing a wetted pencil tip on wetted paper. When dry, apply a pale pencil, such as cream or white, to give a glazed area of light.

▲ Hold several coloured wetted pencil points together and blend them on a brush (like a palette), then transfer them onto a wetted surface to diffuse together.

Pens

Fibre-tip, felt-tip and marker pens are available in a wide variety of types and colours, and you will need to try various types to see which you prefer. For these illustrations, watersoluble art pens have been used. They have a fine firm point at one end, and a useful flexible brush tip at the other end. You can buy similar, waterproof ones, which are spirit- or alcohol-based. These are perhaps a little better for overlaying colours, but they do have a tendency to 'bleed through' the pages of cartridge paper sketchbooks.

▲ The firm point of the art pen is excellent for lively drawing, but there is little variety in the line.

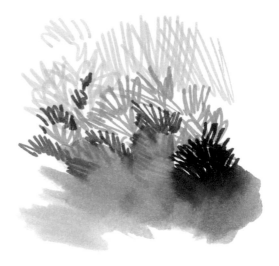

▲ Try different colours and shades together, and use scribble and cross-hatching. Float a little water over the bottom and see the ink dissolve into a soft wash.

▲ Use the brush tip swiftly and freely, occasionally pressing firmly and then reducing the pressure to produce finer lines.

▲ Try some 'feathering': lines that are laid down side by side. Notice the dark tone where the rows overlap. Leaving some white paper adds sparkle.

▲ Using the brush tips of two different colours, see how a third colour is created when the second colour is applied over the first.

▲ Block in a light tone using the brush tip, then add a darker tone underneath. Work over the top straight away with the fine point. The line remains crisp on dry paper, but where you touch the areas of blocked-in colour, the line will 'bleed'.

MATERIALS AND TECHNIQUES

Watercolours

If you practise the basic essential techniques needed to apply watercolours, you will soon discover how the washes behave and how your brush, paper and paint act together. These exercises use three colours.

▶ Wash

The colour needs to graduate smoothly from dark to light. Practise on dry paper (as here) and on wetted paper. Gradually add more water to the colour in your palette to make it lighter as you work up from the thicker and darker first stroke.

▲ Graded colour wash

Work the same as the wash, but start at one side and blend in another colour as you work over to the other side. Keep the paint watery.

▲ Soft and blended edges

Wet the whole area, and then place in a light centre. Now slowly add darker colours to the outside, using plenty of water.

▲ Wet-into-wet technique

This is where you place wetted colours onto a wetted surface and let them diffuse into each other. Try rocking the paper.

◀ Blocking in and brush strokes

Fill in a square, blending to obscure the individual brush strokes. Then apply a variety of strokes using a brush on its side, edge and tip. Finally, dry the brush with a tissue, and try some dry brush strokes.

◀ Lifting out

To create an area of light within your watercolour wash, lift the area out using a dry tissue or brush. There will be some staining, and some papers are better than others for lifting out.

Masking fluid

This is used to mask off selected areas of a painting when a wash is being applied over the top. It can be drawn on with an applicator (a ruling or drawing pen) in a tight and delicate design, or flicked on with an old brush for a more random design. Add a drop of watercolour colouring to colourless fluid so you can see where you have applied it. Dry thoroughly, add a watercolour wash and let this dry before rubbing the masking fluid off with your fingers.

▶ Draw a design with masking fluid in a ruling/drawing pen. Let it dry, then wash over the top. Let this dry and rub off the masking fluid to reveal the first drawing on the white paper.

◀ Paint an undercoat in one colour and let it dry. Apply a design in masking fluid, and once this is dry wash over with another colour. When this has dried, rub the masking fluid away to display the drawing with the first colour gleaming through.

Salts

These offer a lovely effect when sprinkled into a very wet watercolour wash. Different salts give different effects, and this technique is marvellous for snow, seas and foliage. Once the paint and salt are dry, the excess salt can be rubbed off.

▲ A different design created using flake salt.

▲ Use table salt for these small dotted markings.

▲ Create a mottled, sponged effect with rock salt.

▲ The pebbled design is formed with dishwasher salt.

Mixed media

Now try mixing your media. As you can see from the illustrations below, you can create some wonderful effects, which will lead to some exciting and vibrant sketches. We have tried a few different options. Do not be afraid to experiment in order to discover even more.

▲ Make some lines with a pencil and then use the brush tip of a watersoluble art pen over the top. The lines here suggest sky and cloud, so blue was chosen. The brush marks were melted with clean water.

▲ Use the side of a piece of charcoal first, flat against the paper. Blend the marks with a finger. Then use black and sanguine conté over the top, and finally pick out light shapes with a tiny piece of putty eraser.

▲ Make some lines with the fine tip of an art pen. Then use some coloured pencils gently over the top. Begin with your lightest colours. Where you overlay the colours, subtle new ones will be created.

▲ Create a block of colour with the brush tip of an art brush pen. Then 'dissolve' the marks with water, using a paintbrush. Use pastel pencils over the top, feathering the lines so the underneath colour shows through.

want to know more?

Take it to the next level...

Go to ...
► **Composition** – page 36
► **Foreground & distance** – page 40
► **Light, shade & shape** – page 42

Other sources
► **Art shops**
 try different materials
► **Art classes**
 many colleges offer painting courses
► **Specialist magazines**
 The Artist, Leisure Painter and _Artists & Illustrators_
► **Publications**
 visit www.collins.co.uk for Collins art books

composing

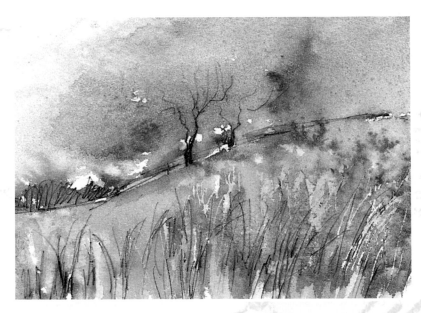

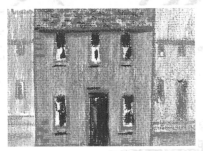

a picture

This chapter gives you some helpful ideas about how to depict light and shade for believable shape and form, and how to organize your images to make a picture that 'works'. Understanding the basics of what constitutes a good design will help you to create a more considered image which has impact, is strong, and visually pleasing.

Composition

There are times when you want to sketch a whole scene, or produce a sketch with a view to making a painting of that subject at a later date. Composing a picture is not always easy. Every part of the picture has to be considered – not just the objects within in the scene but the spaces between the objects too. Composition is how you put all these parts together to make a satisfying whole.

Making a viewfinder

The first thing you need will become one of your most useful tools. It is a viewfinder. Every time we turn our heads, even a tiny bit, we see more and more of a view, and it's really hard to know where to begin and what to include. A viewfinder helps to isolate a section of a view, and shows us what the picture might look like.

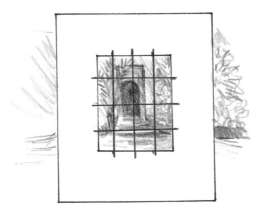

◀ You can cut a viewfinder from a piece of stiff card. The minimum size should be 15 x 10 cm (6 x 4 in). Some artists find it helpful to tape lengths of black cotton across their viewing window, to create a grid. This makes it easy to check the positions of objects in relation to each other.

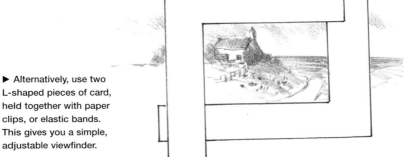

▶ Alternatively, use two L-shaped pieces of card, held together with paper clips, or elastic bands. This gives you a simple, adjustable viewfinder.

COMPOSING A PICTURE

Creating a focal point

A good way to begin a sketch is to decide upon a centre of interest – technically known as a focal point – and then place this focal point on one of the 'eyes' of the rectangle that you see through your viewfinder. This concept has been used by artists throughout the ages, after discovering that the viewer's eye naturally gravitates to these points. It is based on a fairly complex formula, but the principle can be simplified in this way.

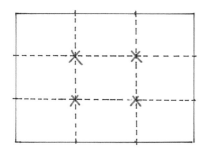

◀ Divide your rectangle into thirds. This will create four points where the lines intersect, and any one of these points is a perfect spot to place your focal point.

▶ The focal point of this sketch – the house that is nestling in the hills – sits perfectly on the top left 'eye' of the rectangle.

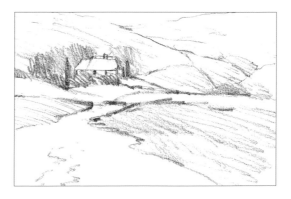

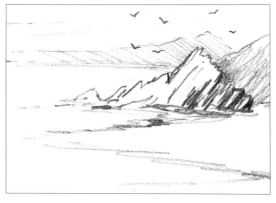

◀ Here, the jagged rocks are the main subject of the picture, placed on the top right 'eye' of the rectangle. The makes the picture feel nicely balanced.

Counterchange

You can stress the importance of your focal point by using strong, dramatic contrasts – setting the lightest part of the picture against the darkest part, or vice versa. This use of light against dark and dark against light is called counterchange; it is very effective indeed, and you should look for opportunities to use it whenever you can. Do not be afraid to exaggerate nature a little if it helps to do so.

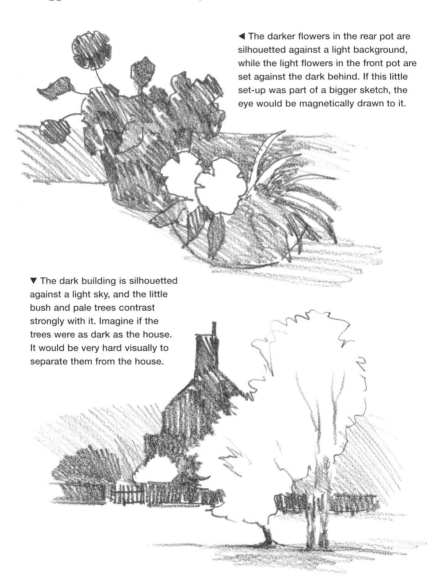

◄ The darker flowers in the rear pot are silhouetted against a light background, while the light flowers in the front pot are set against the dark behind. If this little set-up was part of a bigger sketch, the eye would be magnetically drawn to it.

▼ The dark building is silhouetted against a light sky, and the little bush and pale trees contrast strongly with it. Imagine if the trees were as dark as the house. It would be very hard visually to separate them from the house.

Dos and don'ts

Here are a few pictorial dos and don'ts to consider.

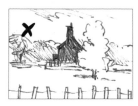

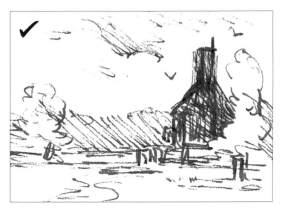

Don't place your focal point in the middle of the picture, and try not to divide your picture in half. Also, don't block off the picture with a fence or wall at the bottom.

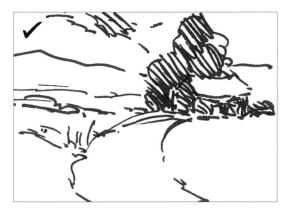

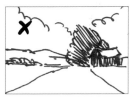

Beware of corners – they can act as arrows leading the eye out of the picture. The picture on the left is far more 'comfortable' and we are led directly to the focal point.

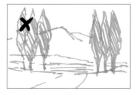

Although it's good to have similar shapes in a picture, which echo each other, vary their proportions, and don't create 'bookends' at either side of a picture, with shapes of equal size.

Foreground & distance

A piece of paper is two-dimensional – it has only height and width. The challenge of painting is to create the illusion of depth, giving it the three-dimensional appearance of reality. You can do this by employing both differences in scale and advancing (warm) and receding (cool) colours.

Identical objects

To practise creating an impression of depth in your picture it is best to begin by experimenting with objects that are of identical size and a simple shape.

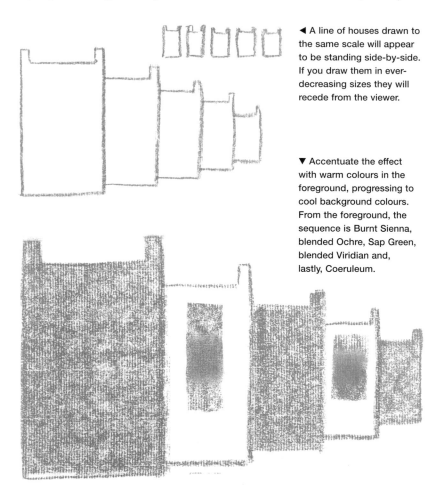

◀ A line of houses drawn to the same scale will appear to be standing side-by-side. If you draw them in ever-decreasing sizes they will recede from the viewer.

▼ Accentuate the effect with warm colours in the foreground, progressing to cool background colours. From the foreground, the sequence is Burnt Sienna, blended Ochre, Sap Green, blended Viridian and, lastly, Coeruleum.

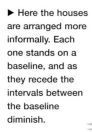

▶ Here the houses are arranged more informally. Each one stands on a baseline, and as they recede the intervals between the baseline diminish.

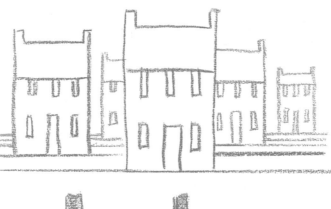

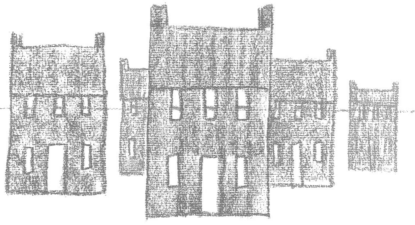

▲ The blue line represents your eyeline, which in this instance is from an upper window. It shows that the houses are of similar size and are on level ground. Such construction lines can be erased when they are no longer needed.

▼ Detail and contrast become more indistinct with distance. It helps here to view the subject with your eyes half-closed.

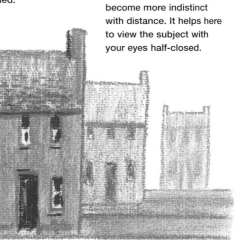

Light, shade & shape

The depiction of light and shade (tone) helps the viewer's eye to recognize objects and adds solidity to their form. However, painting is made easier if at first you ignore the question of tone and concentrate upon finding the basic shapes of the objects.

From squares to cylinders

Shapes distort when viewed from above or below so it is advisable for beginners to choose a central eyeline, indicated here by a blue line.

❶ A precise demarcation of flat tone would turn this square into a cube, whereas the gradual blending of tone will change it into a cylinder (right).

❷ For a cylindrical shape, start by painting a wide band of colour. Then you can add progressively darker or lighter narrowing bands to either side (left) and blend them.

You can see how solid colour gives the appearance of a matt surface (centre), while leaving some white paper gives a glossy effect (right).

Triangles, pyramids and cones

As with squares, cubes and cylinders, triangular shapes distort when seen from an angle. Again, choose a central view as shown here by the blue line.

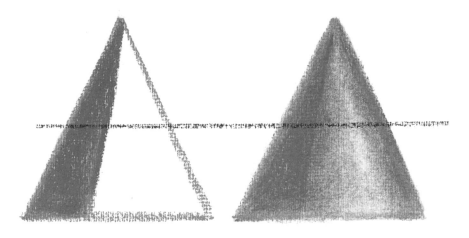

❶ This triangle looks like a pyramid when divided into two flat areas of tone (left). With the tone gradually blended, the same shape becomes a cone (right).

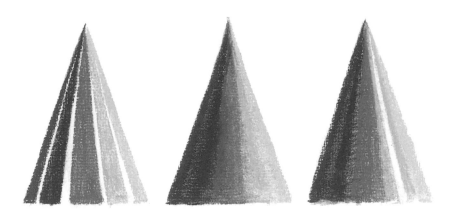

❷ Tonal changes radiate from the top of a cone. Place the widest central band of colour first, followed by the lightest and darkest tones to either side (left). Blend the colours, covering the paper entirely for a matt surface (centre) and allowing some white paper to show through to give the appearance of a glossy surface (right).

Circles and spheres

Unlike square and triangular shapes, circular objects retain their shape whatever position they are viewed from. Consequently, there is no need to establish a particular eye level.

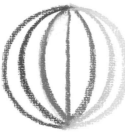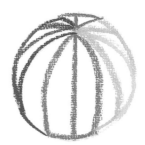

❶ Draw a circle, then add sections either side of a central axis (centre) or radiate

them from any point, flattening them on the opposite side (right).

❷ Infill the colours, graduating the tone and covering the paper entirely for a matt surface (left) or lifting a highlight for a glossy one (right).

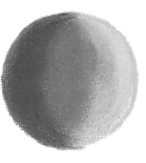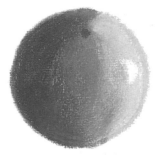

❸ The angle of light from the top of an object to its baseline will determine the length of a cast shadow. The illustration on the left shows the shadow cast at noon. In the illustration on the right, the time could be either mid-morning or mid-afternoon.

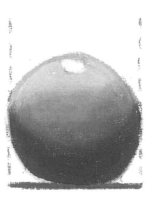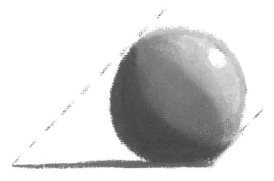

Combining shapes

Most objects consist of a combination of triangular, rounded or squared shapes. Make diagrammatic drawings of the domestic items that surround you, taking care when establishing your eye level (shown here by a blue line).

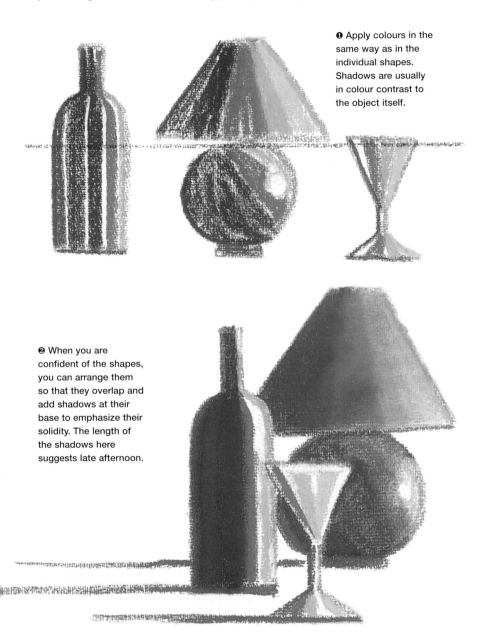

❶ Apply colours in the same way as in the individual shapes. Shadows are usually in colour contrast to the object itself.

❷ When you are confident of the shapes, you can arrange them so that they overlap and add shadows at their base to emphasize their solidity. The length of the shadows here suggests late afternoon.

Making objects 3-D

Most objects are three dimensional; we have to find a language to translate three dimensions into a flat, two-dimensional drawing. Drawing the outline of the object isn't enough to give the impression of three dimensions – the 'form' of the object. Shadows will help to describe the form – sometimes the object will have lines 'within' it that will help, too.

Form

Try copying this example. Then find similar objects at home and draw them using the same principles to describe the three-dimensional form. Use a 2B pencil for this sketch.

❶ Here is a simple, amorphous shape. It could be anything – it could certainly be flat, like a coaster. Or it could be a hole!

❷ Some 'internal' lines have been added. The object now has form – it is full, round, and has bumps. Notice how the overlapping lines explain the cauliflower's form. Also, see how the lighter lines on the left give the impression of light falling on the object.

▲ How you draw your 'internal lines' makes a difference, too. See how straight lines give the impression of a flat surface.

▲ Placing a series of curved lines both up and around the circle gives it a feeling that you are looking at a round object.

▲ The series of lines thicken as they come towards you: if they were exaggerated at the front, the ball would appear even more curved.

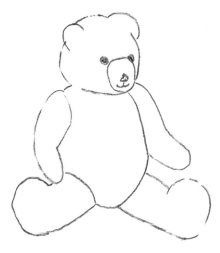

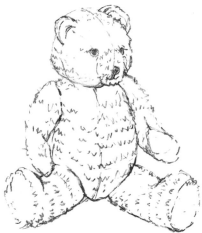

❶ The outline (in red conté) is almost enough to tell us that the toy teddy bear is fat and roundish. However, the line here is quite monotonous, making him look rather like a cartoon bear.

❷ In this drawing, the small lines used to describe the bear's fur curve around his shape. The central line, used to 'search out' the shape of his head, has been left; this helped to plot his features in the right place.

Shadows

Light, when it falls on an object, will usually cast a shadow, and that shadow will help to describe the shape of the object.

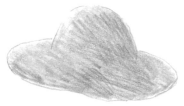

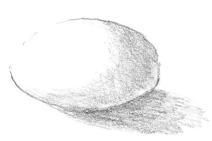

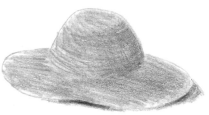

▲ The shape of the egg quickly becomes easy to read when a strong light from the left casts a shadow. 'Tone', which is just another word for shading, was scribbled on, using the side of a 2B pencil held almost flat against the paper.

▲ See how the shape of the hat comes to life in three dimensions when the shadow is added. The blue lines curve around the hat's crown, reinforcing the impression of roundness, while straighter blue lines are used for the shadow on the brim. Wax pencils were used for this sketch.

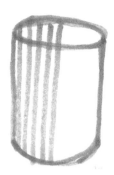

◄ This cylinder appears flat as the shadows are not correct.

▶ Place in an arrow as a reminder of the light source, then readjust the shadows. Remember that light against dark shows form and shapes and will make an object look 3-D.

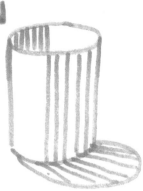

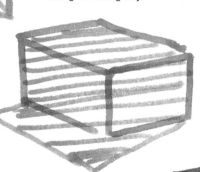

◄ This carrot looks like a cylinder on its side. A darker line has been placed under it, giving a feeling of weight and stability.

▼ This box looks odd because the shadows are falling the wrong way.

▲ The shadows have been corrected to give contrast and depth.

▶ The present has a ribbon that wraps around the whole structure, giving it form. The decoration colours appear light in the shadows and dark in the light. This also helps with the realism.

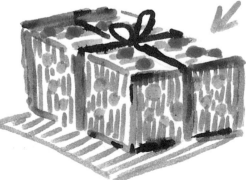

Edges

Be careful not to draw a hard line all around your subject, unless you are drawing an 'edge'. Developing an awareness of the difference between an 'edge' and continuous form is important.

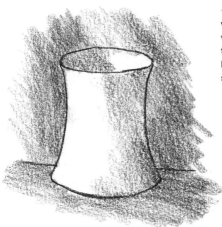

◀ In this conté drawing, the outline of the vase was drawn, then the tone or shading was added. The lines used to describe the top and bottom edges of the vase are fine, but those describing the sides of the vase seem to bring them forward.

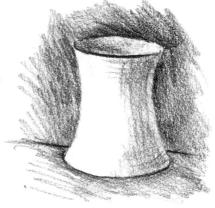

▶ A line is used for the front top edge and bottom edge of the vase, but the dark tone behind 'describes' the sides of the vase, improving the illusion of a curving form.

❶ The apple was drawn with a watersoluble art pen, deliberately leaving a broken line on the left in order to suggest light falling on the fruit from that side.

❷ The line was then wetted, teasing the colour out to form a shadow on the table top, and leaving white paper in order to suggest the lightest part of the apple.

One subject – different approaches

An excellent way to explore the wide range of material mixtures is to try out one subject in a variety of ways, moving it around compositionally. This example uses the corner of a cornfield. Each composition emphasizes the different ways in which you can tackle one subject. By brightening, darkening or detailing one point or by introducing an undulating line, the eye is carried to a different part of the picture.

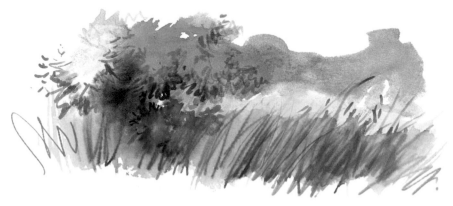

▲ The sky, background and tree are flowed in with washes of coloured inks on wetted paper. When partially dry, the corn and tree details are added with fibre-tip pens.

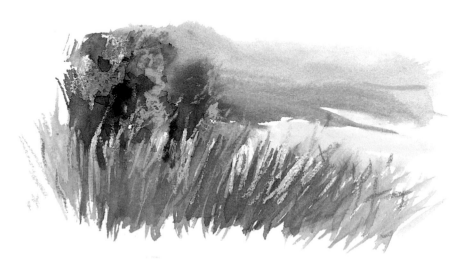

▲ The texturing of the cornfield is applied with pale oil pastel. Using several colours makes the contrast more exciting when watercolour washes are applied.

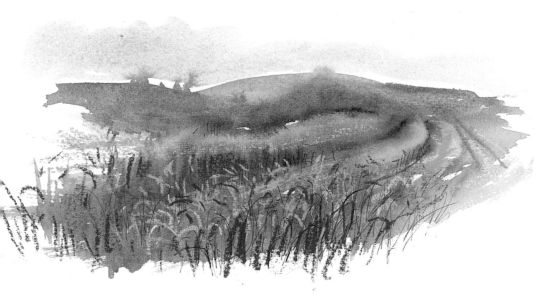

▲ The distant feel is created using a watercolour base, separating and darkening the foreground. Waterproof ink and soft pastel give the highlights and details, and the foreground ears of corn are enlarged to reinforce the feeling of space.

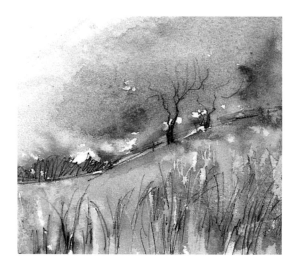

▲ Non-waterproof black ink details of the trees, grasses and distant hills are washed over with watercolour. Whilst still very wet, salt is dropped into the watercolours, mottling the trees with the mid-distance and foreground corn. When it is totally dry, the salt is rubbed off and then a few more grasses are added to the foreground.

want to know more?

Take it to the next level...

Go to ...
- ▶ **landscapes** – page 136
- ▶ **buildings** – page 166
- ▶ **the seaside** – page 176

Other sources
- ▶ **Photographs**
 useful sources of reference
- ▶ **Art shows**
 look out for local or national events
- ▶ **Internet**
 interactive CD-ROMs
- ▶ **Videos**
 from Teaching Art and APV Films
- ▶ **Publications**
 visit www.collins.co.uk for Collins art books

fruit and

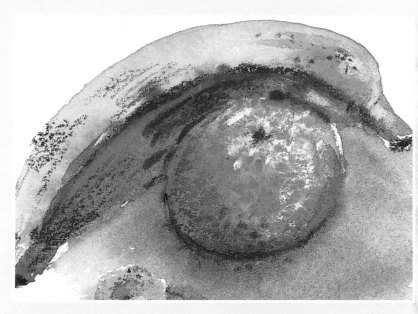

vegetables

Fruit, and vegetables, are the most wonderful things to draw. They have natural form: shapes which are organic and flowing, not man-made and rigid. They offer plenty of colour and variety of texture, too. Although most oranges may form perfect spheres, other fruits and vegetables will have particular shapes, so observe them closely.

▶ Drawing fruit

In this chapter, we will look at some of the most important elements of drawing – how to begin, combining objects, creating texture, and assessing proportions. Fruits and vegetables are great starting points for learning how to sketch. Because they are natural forms, they all differ, so we have to look really hard to find the correct shape.

Pear

Although a 4B pencil was used for this drawing, you can use any grade of pencil for this exercise. Work lightly to begin with.

❶ Pears are great fun to draw. Start off by drawing the shape with a 4B pencil. A broken line may help to give you confidence.

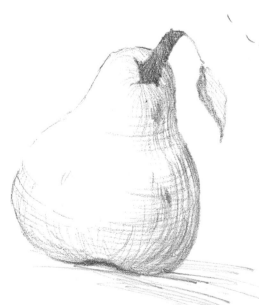

❷ Now you can 'firm up' the line, perhaps leaving it light and open where the light hits the pear. This emphasizes the sense of three dimensions. For the shadowy side, use lines which curve around the form, 'feeling' the shape of the pear with your pencil. Where the shape changes direction, allow your lines to change direction. Build up the shading gradually, pressing hardest for the darkest parts.

Nectarine and banana

Now put two fruits together, one overlapping the other, to practise putting objects together convincingly. This time, a piece of charcoal is used.

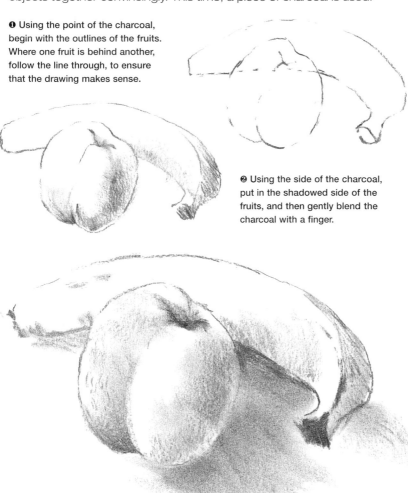

❶ Using the point of the charcoal, begin with the outlines of the fruits. Where one fruit is behind another, follow the line through, to ensure that the drawing makes sense.

❷ Using the side of the charcoal, put in the shadowed side of the fruits, and then gently blend the charcoal with a finger.

❸ Add the shadow on the table top, looking hard to see which is darker, the shadow or the fruit. Build up the form of the fruits. Add any tiny details, such as markings on the banana. If you want to 'lift' any unwanted charcoal, to refine the drawing, use a tiny piece of putty eraser. When you finish, spray the drawing with some fixative. (Notice the tiny area of reflected light on the shadowy underside of the nectarine. When you place an object on a light surface, reflected light often bounces up onto it.)

Strawberries

It is not necessary to draw with a graphite pencil and then colour your sketch in. Working directly with a coloured pencil will immediately capture the colour of the fruit.

❶ Begin by drawing the main shapes of the strawberries. Sketch the outline and also some internal lines to show fullness, crevices, and where the shape changes direction.

❷ This time, begin with the darker areas, and use directional strokes which explain the form, curving round the fruit and down the sides.

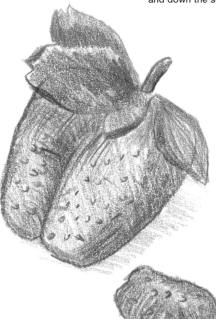

❸ Build up the colour gradually, leaving slightly paler areas where the light strikes the strawberries and their leaves. Tiny half-circles suggest pips. Use short strokes of green for the shadow on the table top.

Coloured pencils

red-orange green

Painting strawberries in mixed media

Strawberries always make my mouth water. Their textured surface makes them interesting to paint. The leaves are a delightful contrast, like a green hat!

Watercolours

Olive
Green

Vermilion

Alizarin
Crimson

Soft pastels

orange

pink

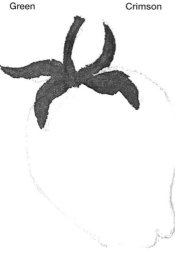

❶ Draw the strawberry in pencil. Paint in the top using green mixed with a little Vermilion.

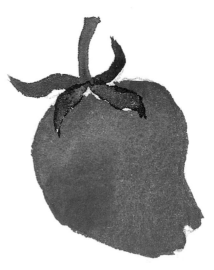

❷ Block in the fruit shape with Vermilion.

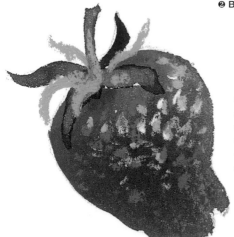

❸ While the paint is still wet, drop in some Alizarin Crimson to darken the colour to show form. When it is completely dry, apply dots of soft orange and pink pastels. Spray with a fixative if required.

Orange

Oranges are simple in shape and painting one is relatively easy. However, you need to take care over the textured feel of the skin as casual stippling could have a flattening effect. Notice how the stippling on the fruit is flatter and thinner at the circumference.

Pastels

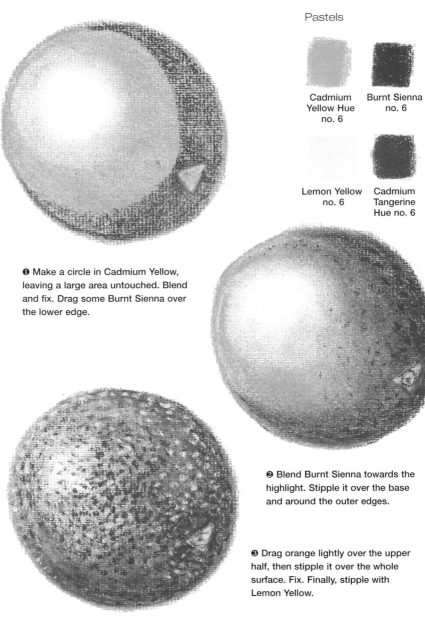

Cadmium
Yellow Hue
no. 6

Burnt Sienna
no. 6

Lemon Yellow
no. 6

Cadmium
Tangerine
Hue no. 6

❶ Make a circle in Cadmium Yellow, leaving a large area untouched. Blend and fix. Drag some Burnt Sienna over the lower edge.

❷ Blend Burnt Sienna towards the highlight. Stipple it over the base and around the outer edges.

❸ Drag orange lightly over the upper half, then stipple it over the whole surface. Fix. Finally, stipple with Lemon Yellow.

Plums

Plums have no pattern to describe their shape and no obvious texture, but if you look carefully you will often find that the skin has a bloom to it. This is texture in its subtlest form, shown by gently dragging a light colour over a dark one.

❶ Drag a short length of red pastel in two overlapping ovals, then overlay with a partial outline in purple. From some viewpoints a plum displays distinct halves.

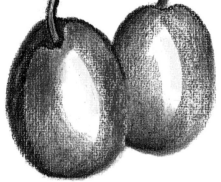

❷ Add yellow in the highlights. Extend and deepen the red. Blend purple into the red, but maintain the crease. Draw yellow over the purple stalks in order to create a mix.

Pastels

Crimson Lake no. 4	Mauve no. 5

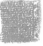

Lemon Yellow no. 6	French Ultramarine no. 1

❸ Drag orange lightly over the upper half, then stipple it over the whole surface. Fix. Finally, stipple with Lemon Yellow.

Shiny cherry

First of all, let's try a very simple project: creating a shine on these cherries, using four different techniques, each giving a slightly different result.

▶ Paint in the cherry (using Alizarin Crimson and a little Vermilion). Apply a gentle shine with a dry white watersoluble pencil.

▶ Paint the cherry, then draw the highlight on the dried paint with a pale cream or white oil pastel. The pastel could be drawn first as it would resist the red paint.

▶ Use masking fluid for the shape of the highlight, then paint the cherry over the top. Once this is dry, rub the masking fluid off.

▶ Add a bright, convincing shine to the cherry by painting on a highlight of white gouache.

Watercolours

Alizarin Crimson

Vermilion

FRUIT AND VEGETABLES

Rosy apple

Apples vary enormously in their colour and patterns and they are relatively easy fruit to paint. However, you can make them more of a challenge by cutting them in half to expose the core with its seeds.

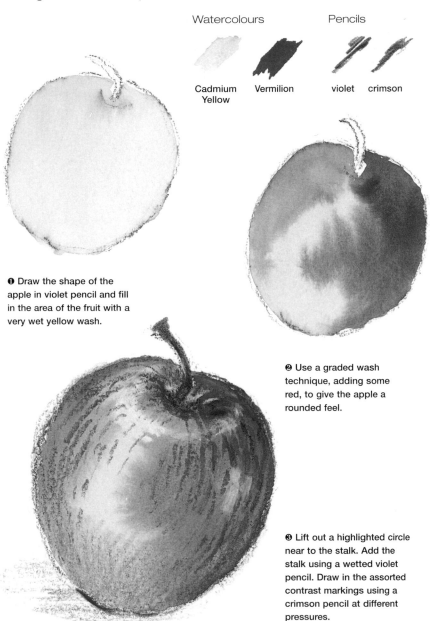

Watercolours

Cadmium Yellow Vermilion

Pencils

violet crimson

❶ Draw the shape of the apple in violet pencil and fill in the area of the fruit with a very wet yellow wash.

❷ Use a graded wash technique, adding some red, to give the apple a rounded feel.

❸ Lift out a highlighted circle near to the stalk. Add the stalk using a wetted violet pencil. Draw in the assorted contrast markings using a crimson pencil at different pressures.

Fruit sections

Cutting fruit into segments will give you unfamiliar shapes to sketch. This is a very good way of training eye/hand co-ordination. Try really hard to get the proportions right, just by eye. Conté was used for these sketches.

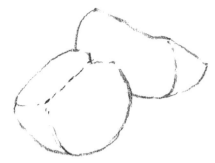

❶ Cut an apple into segments. Set two pieces together, and before beginning to draw them, blur your vision by squinting so that you can only just see the pieces. Looking at them in this way will eliminate all detail, and will fuse the two shapes into one, larger shape. Try drawing the outline of the two together, looking hard at the shape created where they overlap.

❷ When you are satisfied with your large shape, look to see where the 'planes' of the segments change. The top, central line of my front segment was not in the centre, as you might have expected.

❸ Finish off the sketch by putting in the tones of the shadowed sides of the fruit, and the shadow on the table. The table shadow is darker than the fruit shadow.

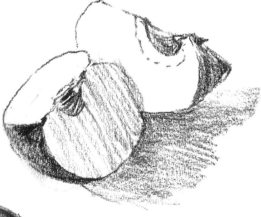

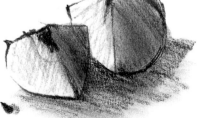

◀ These tiny segments – a quarter cut in half again – do not look at all like apple, but you just have to draw what you can see.

FRUIT AND VEGETABLES

Mouthwatering melon

By cutting this fruit open, you will be painting a different, more complicated shape, and adding the details of the seeds, flesh and skin.

Pen Pencils

sepia yellow violet cadmium orange blue
 ochre yellow

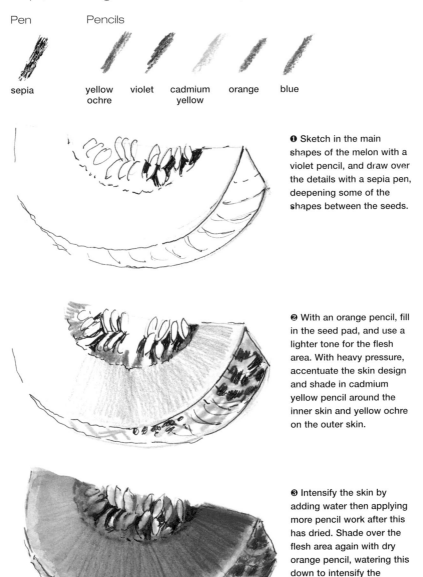

❶ Sketch in the main shapes of the melon with a violet pencil, and draw over the details with a sepia pen, deepening some of the shapes between the seeds.

❷ With an orange pencil, fill in the seed pad, and use a lighter tone for the flesh area. With heavy pressure, accentuate the skin design and shade in cadmium yellow pencil around the inner skin and yellow ochre on the outer skin.

❸ Intensify the skin by adding water then applying more pencil work after this has dried. Shade over the flesh area again with dry orange pencil, watering this down to intensify the texture and colour. Anchor the image down using a blue pencil wash and some loose scribbles for the shadows beneath.

EXERCISE Sketch a fruit still life

You can copy this sketch, but then you will find it rewarding to set up your own still life, using similar fruits. If strawberries are out of season, use any other small fruits, to give a change of scale from the larger pieces.

The palette
4B pencil

lightest tone medium tone darker tone darkest tone

❶ Set up the fruits with the light coming from one side. Using a 4B pencil, lightly sketch the outlines of the fruits. It helps to straighten curved lines a little, as shown here. It can also help to create an imaginary 'grid' in your mind's eye, or even hold out your pencil, to see where the objects line up with each other.

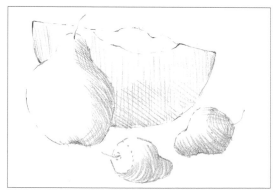

❷ Now half close your eyes and squint at the group. Begin to develop the tone – shading – on the fruit, starting with the darker sides. This should give the fruit three-dimensional form immediately. Try to make your lines 'wrap around' the curved fruits.

❸ Continue to develop the forms of the fruits by adding more shading, looking carefully to define the darkest parts – for example, the shadows under the fruits. Add the shadows on the table top. Begin to define some detail, such as the tiny leaves on the tops of the strawberries.

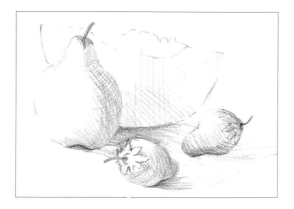

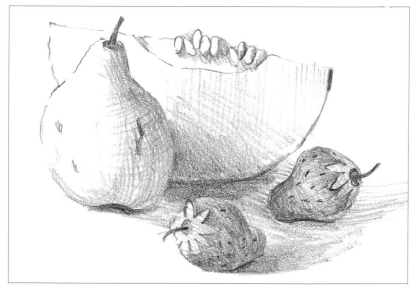

❹ Gradually add more shading. You can take this step as far as you like, even using the side of the pencil lead to close up the lines and darken areas. Finish off with details – the pips on the melon, and the texture on the strawberries.

MUST KNOW

Improve your powers of observation

Because most fruits and vegetables are so familiar to us, it is very easy to fall into the trap of generalizing their shapes and drawing what we THINK is there, rather than observing them very closely and then drawing exactly what we see. If you know that you are inclined to generalize, you should try to break this habit in order to improve your powers of observation.

EXERCISE Paint fruit in mixed media

This is a simple combination of fruit to paint, but it is interesting as the fruits vary in colour and texture. Once you have tried this combination, you can try choosing a different variety and then paint them with the same materials.

The palette

Pastels				Watercolours				
dark brown	cream	orange	light green	Hooker's Green	Yellow Ochre	Cadmium Yellow	Cobalt Blue	Burnt Sienna

❶ Draw the fruit in with a blue pencil. When you are painting a group of objects, place them together in a sympathetic pose, perhaps wrapping one around the other or overlapping them.

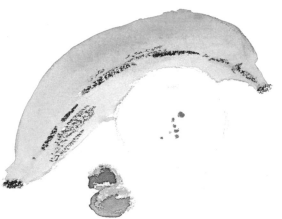

❷ Press cream pastel on to the side of the tangerine, and add orange pastel markings for the texture. Draw a little light green pastel on the grapes and dark brown pastel to show the banana markings. Paint the banana Cadmium Yellow and the grapes green.

❸ Paint the tangerine in Yellow Ochre and complete the orange pastel spotting. Deepen the shadowed area on the banana with brown paint. Use light green pastel to tip the banana at both ends, and accentuate its markings with additional dark brown pastel.

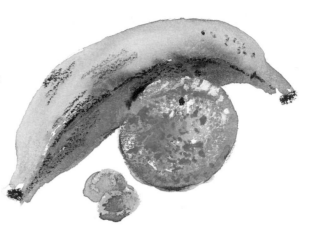

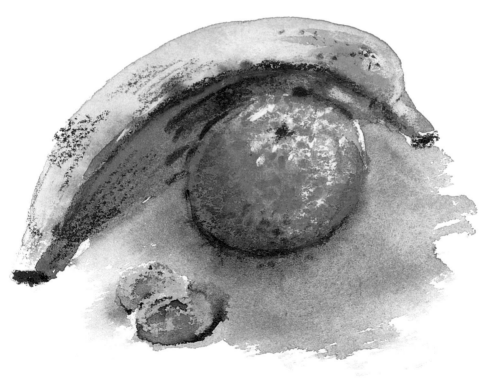

❹ Paint around the fruit with a blue wash. Wash brown paint into the tangerine to heighten the texture marks.

Drawing vegetables

Raid your fridge for a few vegetables to draw. Vegetables come in so many varieties, and so many different shapes and colours. You could devote a lifetime to drawing them!

Onion

The golden rule – although this term is used loosely because there are no 'rules' about drawing – is form before texture. In other words, make the object look three dimensional before you allow yourself to tackle the fun part – the surface texture.

❶ An orange pastel pencil was chosen for this lovely golden-orange onion. First, draw the shape of the onion, and then scribble some tone onto the shadowed side.

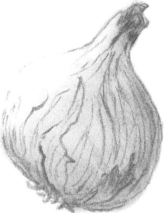

❷ Using a finger, gently blend the pastel strokes into the paper, to create the full, rounded form of the onion. If your blending doesn't look quite right, you can remove some colour with a putty eraser.

❸ Finally, add the texture of the onion skin. By pressing hard, you can suggest the edges of broken skin, while lightly drawn lines, following the form of the onion, imply the 'lines' on the onion.

Papery onion

Onions are an excellent example of the way lines can be used to explain and accentuate a structure, and to add texture. Try not to generalize too much; observe the lines carefully before you draw them in, for an authentic look.

Watersoluble pen Watercolours

sepia Yellow Burnt Cerulean
 Ochre Sienna

❶ Draw the onion with a pencil. Apply masking fluid in lines that separate out and give the onion a good rounded shape, and then wiggle in some roots. Apply a little watersoluble sepia pen to the top and bottom.

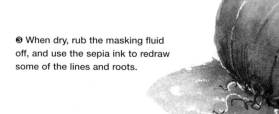

❷ Fill out the body of the onion using a yellow and brown wash, and let the shadows form from the brown ink where it dissolves in the wash. Paint in a blue shadow so that the onion 'sits' on the ground.

❸ When dry, rub the masking fluid off, and use the sepia ink to redraw some of the lines and roots.

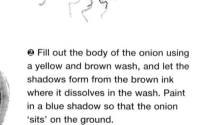

Mushroom

Judging proportions by eye isn't always easy. You can check them by using artists' measuring. Hold out a long pencil, with your arm straight and elbow locked. Don't point the pencil at the object, but at the ceiling (when checking height) or the wall to your left or right (for width). Close one eye, line the top of the pencil up with the top of the object, and place your thumb on the pencil in line with the bottom of the object. This becomes your measuring unit – use it to check all other parts in relation to this unit as you draw.

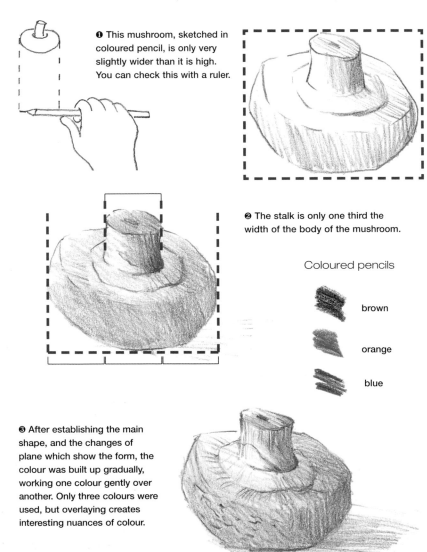

❶ This mushroom, sketched in coloured pencil, is only very slightly wider than it is high. You can check this with a ruler.

❷ The stalk is only one third the width of the body of the mushroom.

Coloured pencils

brown

orange

blue

❸ After establishing the main shape, and the changes of plane which show the form, the colour was built up gradually, working one colour gently over another. Only three colours were used, but overlaying creates interesting nuances of colour.

Yellow pepper

Peppers are also interesting to paint, as their surface is brightly coloured and shiny. After you've copied this one, try painting one cut in half, to show the intricate interior and all the seeds.

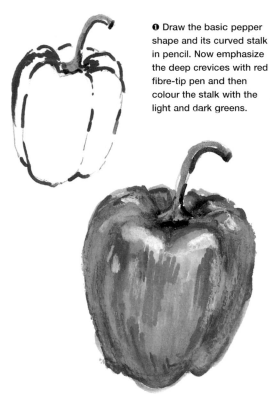

❶ Draw the basic pepper shape and its curved stalk in pencil. Now emphasize the deep crevices with red fibre-tip pen and then colour the stalk with the light and dark greens.

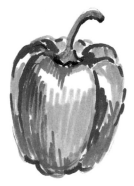

❷ Complete the shape by colouring it in with yellow, using orange for the deeper shaded areas.

❸ Wash over the pen work with water to blend the colours gently. When dry, add highlights to the top and edges using cream and white pastels.

Fibre-tip pens

| orange | red | yellow | light olive green | dark olive green |

Pastels

cream white

want to know **more?**

Take it to the next level...

Go to ...
▶ **shapes and patterns** – page 74
▶ **sketching plants** – page 86
▶ **drawing trees** – page 102

Other sources
▶ **Photographs**
 useful sources of reference
▶ **Art shows**
 excellent for inspiration and ideas
▶ **Sketchbooks**
 good for improving observational skills
▶ **Painting holidays**
 expand your horizons with other artists
▶ **Publications**
 visit www.collins.co.uk for Collins art books

natural

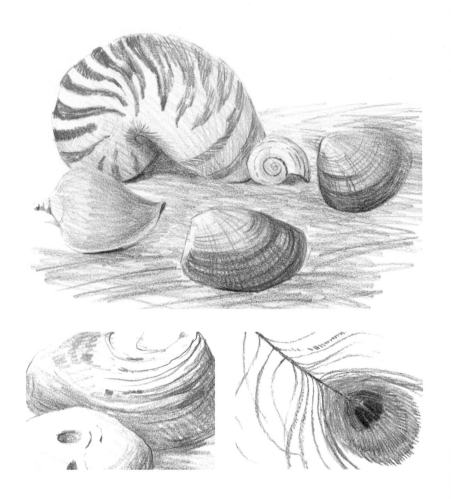

forms

You do not have to go far to find natural forms. A walk in your garden or on the seashore will provide some inspirational objects – stones, rocks, bits of bark, pebbles, roots, feathers, shells, seaweed and barnacles. These may not be as pretty as flowers, or as colourful as vegetables, but they are still fascinating to draw. Collect interesting objects to sketch.

Shapes and patterns

As you sketch natural forms, you will become aware that nature is a wonderful artist. Many natural objects have beautiful shapes, colours and patterns, and sketching these will train you to investigate how things are made as well as how they look. Start with fairly simple items, and build your confidence to tackle more complex forms.

Pebbles

These two pebbles were smooth and round, and one seemed to have a built-in, circular pattern, which echoed its shape. If you look hard to find the natural rhythm of construction and see how the pattern follows the form, this will help a great deal. The danger is drawing the patterns as if they were on a flat surface, which flattens the object.

Coloured pencils

lemon yellow	purple	dark green-blue	green	blue

❶ Begin with the basic outline, using coloured pencils. Where the pattern is strongest, indicate this with some circular lines, which follow the form. You can also add a little tone, to establish the 3-D form.

❷ Gradually add more colour; one pebble is more yellow than the other, which is grey-green. As you build up the colour, try to suggest the pattern while following the form. Finally, put in the little dents and cracks in the front pebble, and then you can add the shadow underneath them.

Feathers

Pastel pencils, sharpened to a fairly fine point, were used for these drawings. You can sharpen a pastel pencil by rubbing it gently on some fine sandpaper. Press lightly when sketching or the point will break.

Pastel pencils

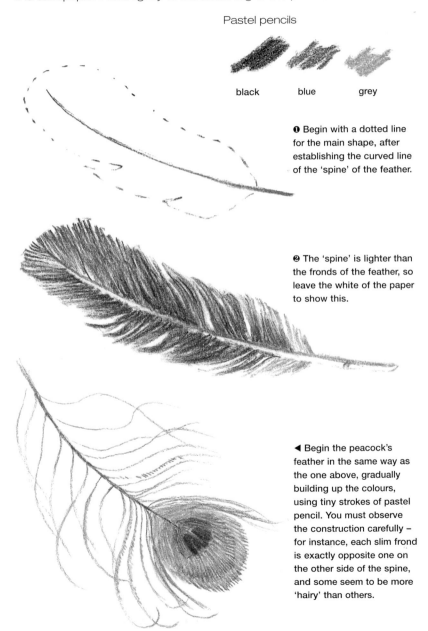

black blue grey

❶ Begin with a dotted line for the main shape, after establishing the curved line of the 'spine' of the feather.

❷ The 'spine' is lighter than the fronds of the feather, so leave the white of the paper to show this.

◀ Begin the peacock's feather in the same way as the one above, gradually building up the colours, using tiny strokes of pastel pencil. You must observe the construction carefully – for instance, each slim frond is exactly opposite one on the other side of the spine, and some seem to be more 'hairy' than others.

Tree bark

Sketching bark will train you to observe well, but also to simplify, because it is almost impossible to include every tiny crack and flake. The pattern is quite complex, and if you do not follow the form in places, you could flatten the shape, and lose the sense of three dimensions.

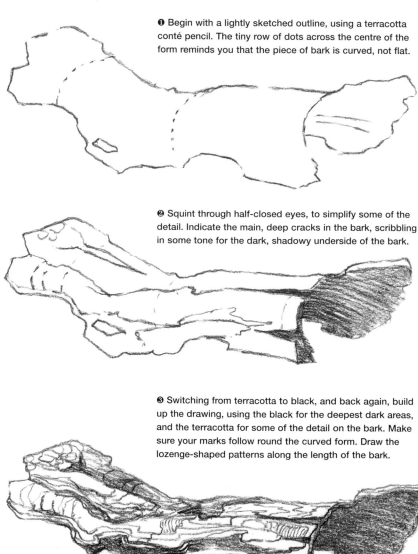

❶ Begin with a lightly sketched outline, using a terracotta conté pencil. The tiny row of dots across the centre of the form reminds you that the piece of bark is curved, not flat.

❷ Squint through half-closed eyes, to simplify some of the detail. Indicate the main, deep cracks in the bark, scribbling in some tone for the dark, shadowy underside of the bark.

❸ Switching from terracotta to black, and back again, build up the drawing, using the black for the deepest dark areas, and the terracotta for some of the detail on the bark. Make sure your marks follow round the curved form. Draw the lozenge-shaped patterns along the length of the bark.

Seed pod

A stick of charcoal was used for these drawings – a thin piece with a point.
To re-point your charcoal, run it gently across a piece of fine sandpaper.

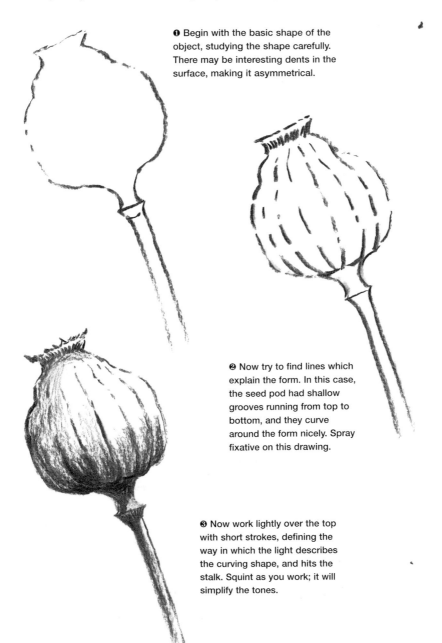

❶ Begin with the basic shape of the
object, studying the shape carefully.
There may be interesting dents in the
surface, making it asymmetrical.

❷ Now try to find lines which
explain the form. In this case,
the seed pod had shallow
grooves running from top to
bottom, and they curve
around the form nicely. Spray
fixative on this drawing.

❸ Now work lightly over the top
with short strokes, defining the
way in which the light describes
the curving shape, and hits the
stalk. Squint as you work; it will
simplify the tones.

Shells

Shells are a delight to look at and a treasure trove for the painter. Collect a few, from the beach or from the marvellous selections in many seaside gift shops, and try out this exercise using different shapes. This is another example of approaching the same subject using different media.

▶ Here the shells are inked in using an art pen with a sepia watersoluble pencil drawing. A little purple watercolour is washed over and more pigment added to the shadows. Pale Yellow Ochre is painted into the shell's grooves.

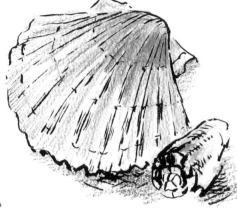

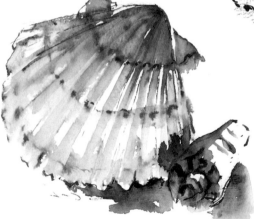

◀ The main skeleton is drawn in using a brush pen, then coloured using dry orange, purple and yellow watersoluble pencils, scribbling them in to give a loose hint of colour.

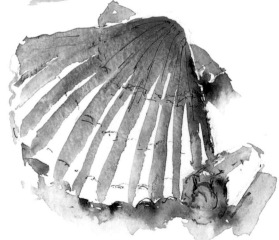

▶ Orange and Violet watercolours are painted into the main shape, emphasizing the texture and structure. Ultramarine is added to the shadows.

Limpets

Shells add interest to water subjects or a still life and are attractive objects on which to practise pastel painting. Find some shells and explore their shapes and growth patterns. Limpets have contour lines like hills on a relief map, but the periwinkle is a free-flowing spiral.

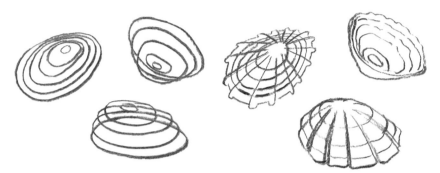

❶ Draw the contours from above, underneath and from the side with charcoal, carefully following the form of the shell.

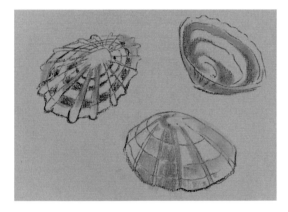

❷ Lightly draw visible contours and radiating lines in purple-grey. Fill the nearer ridges and one inner contour with the darker raw sienna. Blend some of the purple-grey on each shell.

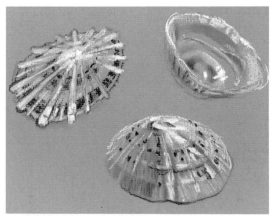

❸ Add the lighter raw sienna. Place purple-grey spots on the front shell and infill the spaces on the grey shell with coeruleum, then add the white highlights.

EXERCISE Drawing shells with wax pencils

Shells can be found in many different shapes and sizes, and instead of drawing them one at a time, put a few together, using shells with similar, harmonious shapes, so that they work well together visually. Consider their placement carefully – overlap their forms in places, look at the spaces between them and create an interesting and balanced design. An uneven number of shells will provide a better design than an even number.

The palette
Wax pencils

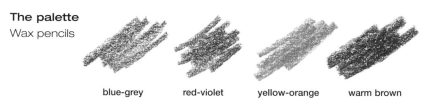

| blue-grey | red-violet | yellow-orange | warm brown |

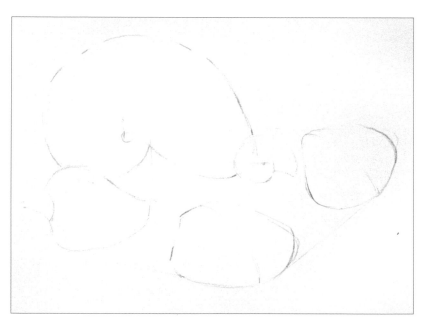

❶ For this picture, you should use coloured wax pencils. Begin with the outlines of the shells, checking the positions of the shells in relation to each other. If you look carefully, you might just see the faint lines that are used for this purpose.

❷ Add tone to show the shadow side of the shells – the light was coming from above and to the left. For the smaller shell on the left, curve the lines to follow the form. For the big shell, simple cross-hatching will suffice, as the pattern is strong and this will come later.

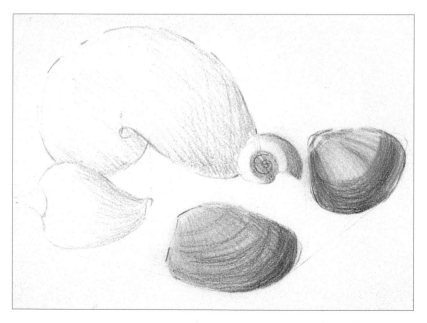

❸ Next, work on the three remaining shells. You should use blue-grey on the smaller shell at the back of the group, and a mixture of blue-grey and red-violet on the purple shells. Make sure that your marks curve around the form.

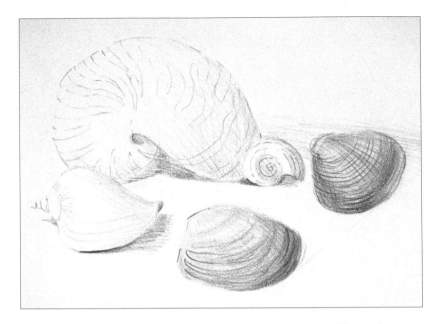

❹ You can use some simple outlines to describe the patterns on the shells, then begin to suggest some of the shadows underneath them.

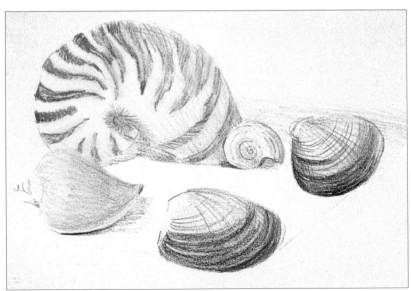

❺ Complete the pattern on the largest shell. The pattern breaks up into lines, and the tone varies from solid and dark, to lighter and finer. Add some yellow-orange to the shell on the left, which is a warmer colour, and emphasise the pattern on the purple shells.

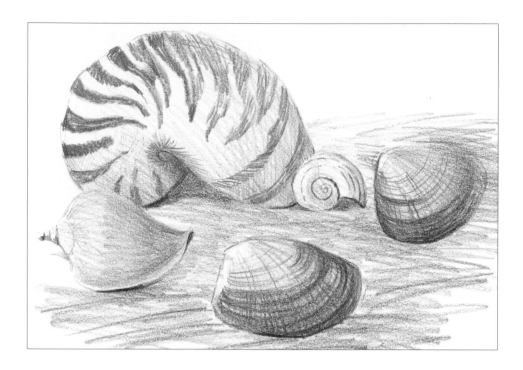

❺ Finished picture: Tinted watercolour paper, 17 x 26 cm (6½ x 10 in). Where the shells meet the ground, there is a dark line; the pattern on the purple shells can be exaggerated a little, and further lines curve over the shell to suggest the form. A little blue-grey stroked across the large shell helps the bottom part recede. Lines of blue-grey, red-violet and yellow-orange are used for the ground on which the shells sit.

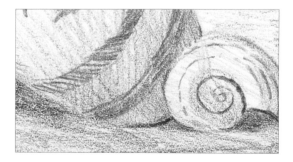

This detail shows clearly how the pattern 'sits' on the top surface of the shells, following the curving form. Even the small shell has a shadow to explain the 'dip' in the shell.

want to know more?

Take it to the next level...

Go to ...

▶ **sketching plants** – page 84
▶ **drawing trees** – page 102
▶ **seaside sketching** – page 178

Other sources

▶ **Photographs**
 useful sources of reference
▶ **Art shows**
 provide inspiration and ideas
▶ **Sketchbooks**
 good for improving observational skills
▶ **Gardens**
 research new painting subjects
▶ **Publications**
 visit www.collins.co.uk for Collins art books

plants and

flowers

Throughout the ages, artists have drawn plants and flowers. We can see the influence of floral forms all around us, in decorative carvings, ironwork, architectural detail, jewellery and fabrics. Their complexity and beauty provide us with a wealth of material, whether we want to produce botanically accurate images, or capture their essential essence.

Sketching plants

Flowers have naturally undulating, rhythmic lines, and you should try to get a little 'flow' in your sketches when you tackle their lovely forms. This doesn't mean that you should sacrifice close observation. You are training your eye and hand, and gradually, fluency will come and, with it, the ability to work more freely. Without the underpinning of good observation, 'free' sketches can become sloppy sketches.

Cosmos: open face

Start with some simple, open-faced blooms such as this Cosmos, before you try more complex, many-petalled flowers which are trickier to sketch. A flower with a simple circle of petals around its centre may seem easy to draw, but it will provide more than enough challenges for the novice artist. Its structure may be straightforward, but you will still need a sharp eye and a sensitive hand to capture its essence in a portrait.

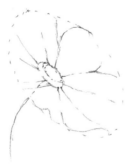
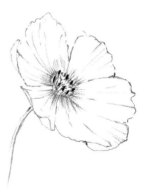

❶ Half-close your eyes to find the main, overall shape. Now find the position of the centre of the flower, and see where the stalk meets the petals – it often helps to follow it through. A 4B pencil has been used for this simple line drawing.

❷ Drawing a flower turning slightly away from you is much more interesting than drawing it 'full-face'. After establishing the structural shape, place the petals carefully, looking hard to see where they overlap, which describes their positions.

❸ Finally, study the beautiful varied edges of the petals, and try to represent them faithfully. Fine lines radiating out from the centre show where the petals are curved, and where they are straighter, describing the form without the use of shading.

Cosmos: underside

The undersides of flowers are also fascinating to study, to see how the petals attach to the stem. This is the underside of a Cosmos bloom.

 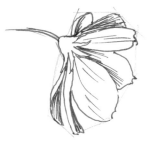 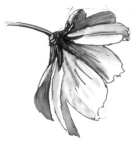

 ❶ Instead of using a simple oval form, look at the flower through half-closed eyes and then draw a box with straight edges to represent the positions of the petals.

 ❷ Draw the flower with the firm point of a watersoluble art pen. Where the petals are in shadow, you can use additional lines to describe the darker tone.

 ❸ 'Loosen' the ink on the darker parts of the petals with a brush and water. When dry, erase your pencil lines and redraw any ink lines that have been washed away.

Lilac

For this slightly more flowing sketch, use just four coloured pencils – green and orange for the stem and leaves, and two purples for the flowers.

Coloured pencils

green orange dark purple light purple

 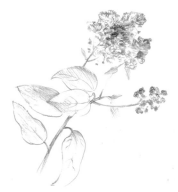

❶ Begin with the stem, sweeping the lines right through and behind any leaves. See how the leaves join the stem, and then give free rein to flowing linear curves.

❷ Hint at the veins on the leaves, since they describe the form. Use dots, dashes and little curving lines for the tiny purple flowers, picking out the odd stem here and there.

Mixing greens

When you paint plants and flowers in watercolour you need to mix different greens. Use some of the ready-mixed greens, such as Hooker's, Sap or Viridian, and then mix in a little Cadmium Yellow or Naples Yellow for the lightest greens; Cerulean, Cobalt Blue or Burnt Sienna for mid-tone greens; and deep Violet, Alizarin Crimson or deep brown for the darkest greens.

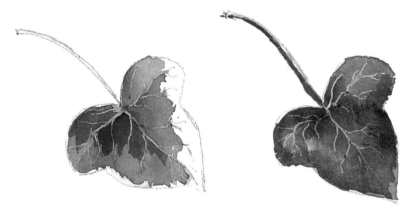

❶ Draw in the basic shapes in pencil and place masking fluid on the veins and stalk. Start painting a red wash over the dried masking fluid and then, over the top, paint green with a little yellow.

❷ Continue to paint the whole leaf and stalk, adding more green to the leaf edges. Adding more green to the edges will make them darker in tone and give an impression of a slight curl at the edge of the leaf.

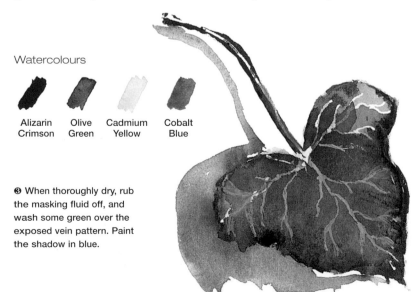

Watercolours

Alizarin Crimson	Olive Green	Cadmium Yellow	Cobalt Blue

❸ When thoroughly dry, rub the masking fluid off, and wash some green over the exposed vein pattern. Paint the shadow in blue.

Simple leaves

Choose three tones of one colour for this basic leaf shape. Yellow-green has been used here, but red or orange would be equally appropriate since leaves can be found in a huge variety of colours and tones.

The crease along the central spine of a leaf creates a division of light and shade. Draw the shape first, fill with close hatching and then fix (left). Next, place the veins alternately on either side, using dark on light and light on dark (centre). If the surface is glossy, lift out highlights between the veins with an eraser (right).

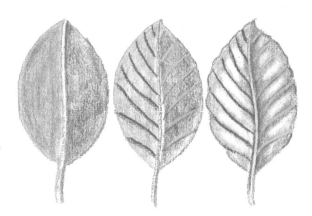

Curving leaves

Leaves often fold and curve and, by doing so, they show both their upper and under surfaces. However, if you observe them carefully, they are no more challenging to paint than a flat leaf.

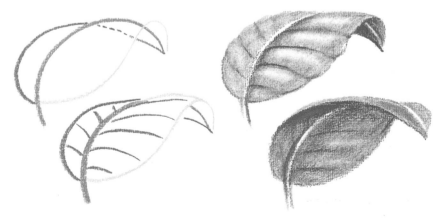

❶ Here orange has been used to show how the spine of the leaf decides the angle of its curl. A dotted line indicates the continuity of the unseen edge.

❷ To show the leaf curving towards rather than away from you, reverse the curl, using a darker green for the main body of the leaf to indicate the shadow on the underside.

Buds

Flower buds are enclosed by a case of leaves that protect the petals and the seed pod. The volume of the closed bud also governs the shape of the subsequent seed pod.

Pastels

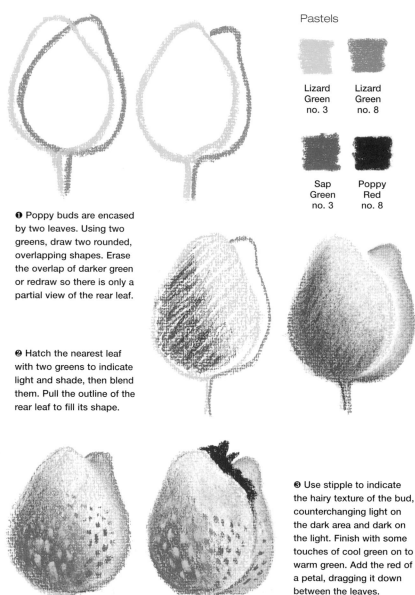

| Lizard Green no. 3 | Lizard Green no. 8 |
| Sap Green no. 3 | Poppy Red no. 8 |

❶ Poppy buds are encased by two leaves. Using two greens, draw two rounded, overlapping shapes. Erase the overlap of darker green or redraw so there is only a partial view of the rear leaf.

❷ Hatch the nearest leaf with two greens to indicate light and shade, then blend them. Pull the outline of the rear leaf to fill its shape.

❸ Use stipple to indicate the hairy texture of the bud, counterchanging light on the dark area and dark on the light. Finish with some touches of cool green on to warm green. Add the red of a petal, dragging it down between the leaves.

Petals

Petals take many forms, from the frilled, complex forms of dianthus to the simple saucer shapes of buttercups. However, they are rarely completely flat, so pay attention to how the light falls on them and alters their colour.

 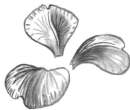 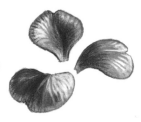

❶ Begin by drawing inwardly and outwardly curved petals, then a foreshortened view.

❷ Draw in pinks and yellows following the line of growth from the base of the petal. Blend in the same direction.

❸ The source of light is to the right. On the inwardly curved petal it strikes the opposite edge.

Tulips

Flowers have natural flowing shapes, and as you practise these shapes your painting will become more fluent, and you will gain the confidence to work more freely. Tulip petals wrap smoothly around each other, and they are gorgeous to paint, particularly when their heads start to droop.

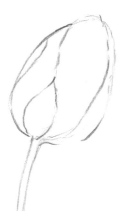 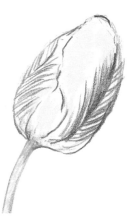 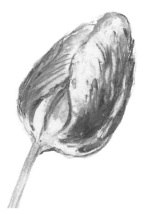

❶ Start off by drawing in the egg-shaped head of the tulip and the flow of the petals in vermilion pencil. Now add a pale green stalk.

❷ Add deeper colours and patterning by drawing yellow soft pastel and red pencil marking on each petal, and green up the stalk.

❸ Wash over with water and let the colours mix. When dry, redraw the red and reapply the yellow to describe the form without shading.

Daisies

A many-petalled flower like the Michaelmas Daisy is trickier than the trio of broad petals on page 91, but you don't have to include every detail. Once you are familiar with its form, you can try painting the whole plant.

Pastels

Mauve no. 1

Mauve no. 5

Green Grey no. 1

Sap Green no. 4

Cadmium Yellow Hue no. 6

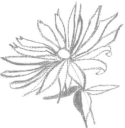

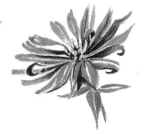

❶ Working upside-down, draw a grey-green stem from the base to the flower centre. Turn the right way up. Outline the petals in mauve and add the leaves.

❷ Erase the upper stem. Infill the petals with mauve, leaving some highlights. Use purple for the shadows and then add some sap green to the leaves.

❸ Make yellow dots for stamens and surround them with purple. Blend mauve into purple on the petals but keep crisp edges on those facing forwards.

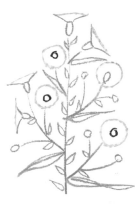

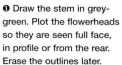

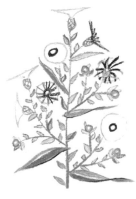

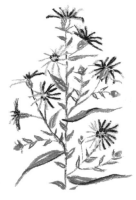

❶ Draw the stem in grey-green. Plot the flowerheads so they are seen full face, in profile or from the rear. Erase the outlines later.

❷ Side stems and junctions have extra leaves. Criss-cross the seed pods and begin to add structure to the flowerheads.

❸ Finally, you can flesh out the detail on the daisy flowerheads, using a darker mauve to show where the shadow falls.

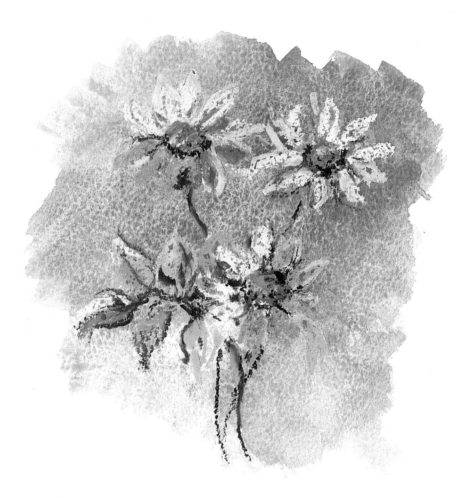

▲ Strong strokes of brown, cream and orange oil pastels are used for the flower heads, and burnt sienna, light and deep green pastels for the foliage and stalks. A blue background is washed over, and the images spring through the watercolour wash. Extra details may be added whilst still wet.

▶ Coloured paper adds 'mood' and gives the flowers an immediate tone. Yellow, white, cream, light and dark green oil pastels are used for the stalks and foliage. A dark wash of Olive Green and blue-green over the background allows the coloured paper to gleam through and unite the picture.

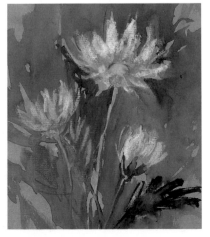

Poppies

Poppies are endearingly attractive with their hairy stems, ragged leaves and blowsy, crumpled petals, but beneath the apparent untidiness and fragility of the flowers there is a governing structure.

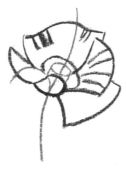 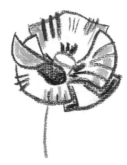 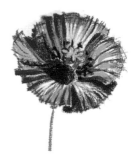

❶ Drawing begins where the stem, petals and seedpod meet. This is easier to see with one petal removed.

❷ Put in red outlines, adding creases for the petal curves. Use darker red for shaded areas; yellow for highlights.

❸ Put in the stamens, then wiggle a line across the petal edges in order to indicate the frills.

Pastels

Sap Green no. 4	Poppy Red no. 8	Indian Red no. 6	Cadmium Yellow Hue no. 6

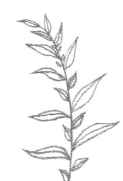 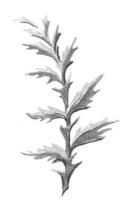 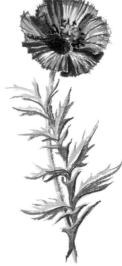

❶ You will find that it is easier to paint spiky poppy leaves if you look at the underlying structure and stem first. They become smaller towards the top. With tracing paper, follow the lines of your initial drawing.

❷ Add some spiky edges to the leaves and draw the tops of smaller leaves across the stem to indicate twists and turns. Now infill the greens, using a darker tone on the underside of leaves where they are in shadow.

❸ Combine the flower and leaves. Overlay it with the leaf stem, balanced in the opposite direction. Develop the leaf with a third green, keeping an open texture. Add hairs to the stem by scratching with a scalpel.

Using watercolours

Understanding how a flower is constructed is vital for painting it correctly. The way the petals fit together and blend or contrast is characteristic of a given bloom. The background will determine the flower's tone and colour.

Pencil Watersoluble ink Watercolours

burnt sienna sepia Yellow Ochre Olive Green Vermilion Magenta

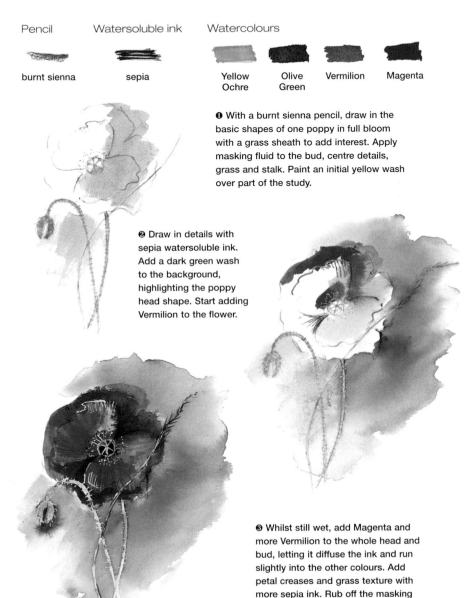

❶ With a burnt sienna pencil, draw in the basic shapes of one poppy in full bloom with a grass sheath to add interest. Apply masking fluid to the bud, centre details, grass and stalk. Paint an initial yellow wash over part of the study.

❷ Draw in details with sepia watersoluble ink. Add a dark green wash to the background, highlighting the poppy head shape. Start adding Vermilion to the flower.

❸ Whilst still wet, add Magenta and more Vermilion to the whole head and bud, letting it diffuse the ink and run slightly into the other colours. Add petal creases and grass texture with more sepia ink. Rub off the masking fluid and soften the white patterns with light yellow, green or watery Vermilion.

PLANTS AND FLOWERS

95

Dandelions

Some flowers are at their most interesting at the seed stage, such as this dandelion. Try copying this example, then find a similar flower in seed, such as an 'Old Man's Beard' or a poppy head, to experiment with for yourself.

❶ Draw in the two heads, placing masking fluid details on one stalk, and drawing a circle of cream pastel on the second stalk. Apply pink oil pastel to the stalks.

❷ Weave a little thread of green and orange oil pastel through the background as trailing weeds. Now mix a dark green and mid-green background watercolour wash, and then apply it over the picture.

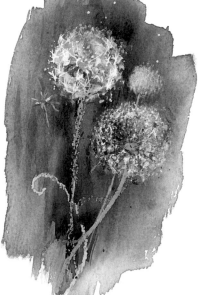

❸ When thoroughly dry, rub off the masking fluid. Splatter some white gouache over the heads to soften the effect. Draw in the remaining details with a dry brown pencil.

Watercolours Pencil

Olive Green brown
Green Gold

Oil pastels

cream pink pale orange
 green

Grouping flowers

Painting a couple of heads of the same flower gives you the opportunity to combine proportions, tones, colours and shapes.

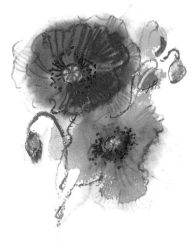

◄ The soft 'halo' effect on the poppies was created by wetting the edges with water before starting to paint the petals. One flower is more dominant and colourful, the other like a softer silhouette.

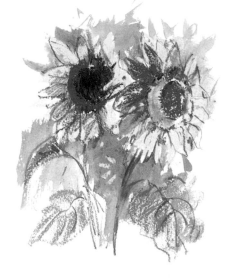

► These sunflowers are in contrasting but complementary tones. The leaves are drawn in emerald and olive soft pastels, the flower petals and centres in orange, burnt sienna and brown. Yellow watercolours give the basic flower colour and some details are outlined with a brown pencil. For the leaf texture, pastels are added to dried watercolour.

Dandelion heads

This picture contains several of the same variety of seed head, created using different painting methods, plus the flower, leaves and buds. It is a delightful array of mixed media.

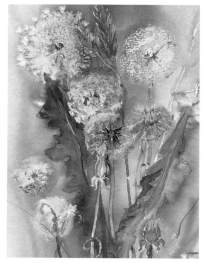

► The top left seed head is created using salt sprinkled into the dark background while it is still wet. Cream oil pastel on the top right seed head resists the wash. The shape of the central bluish seed head is dabbed out using a tissue and splattered with some white gouache. The random seeds (dandelion clocks) are created with salt dropped into the wet background and allowed to dry before working on them.

EXERCISE ## Pot of flowers in pastel

Tackling a small still life, a few simple flowers in a little unpretentious pot, is a great way to give yourself confidence before trying a more ambitious, large vase of flowers, or even a corner of your garden in full bloom. Cut the flowers short, so that their petals overlap the lip of the container.

The palette Pastel pencils

| white | pale green | dark green | yellow | pale blue | pale pink | dark pink | charcoal |

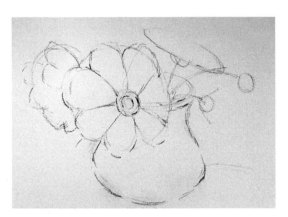

❶ On soft grey pastel paper, using charcoal, sketch the shapes of the flowerheads – circles and ovals. Look at where the centres come – the centre of the big bloom was off-set slightly to the right. Define the shapes of the petals carefully, adding lines of charcoal at the base where the colour is very dark. Charcoal can easily be rubbed off with a putty eraser, so don't hesitate to correct any mistakes.

❷ Spray the drawing with fixative before adding any colour. Work from light to dark. Use pale pink for the lightest parts of the blooms, and pale green for the lightest parts of the stems and the leaves on the buds.

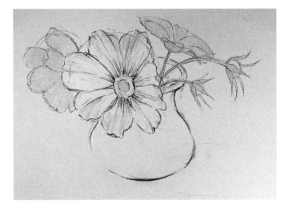

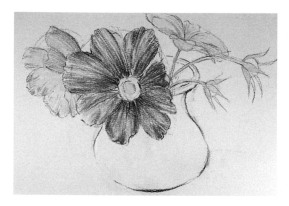

❸ Use the darker pink for the main flower. Make some long and sweeping marks, following the form from the centre to the outer edge. Petals often have little ridges that describe their form beautifully. Notice how the pastel pencil marks blend with the charcoal.

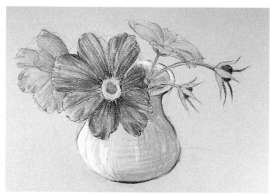

❹ Use white for the left side of the pot, and pale blue for the side in shadow. Curve the marks round the pot from top to bottom and right to left. When the shadow is complete, use the pale blue on the light-coloured blooms at the back, to hint at shadows on the petals.

want to know **more?**

Take it to the next level...

Go to ...
▶ **drawing trees** – page 102
▶ **planning landscapes** – page 138
▶ **seaside sketching** – page 178

Other sources
▶ **Photographs**
 useful sources of reference
▶ **Art shows**
 look out for local or national events
▶ **Gardens**
 will provide subjects and ideas
▶ **Painting holidays**
 expand your horizons with other artists
▶ **Publications**
 visit www.collins.co.uk for Collins art books

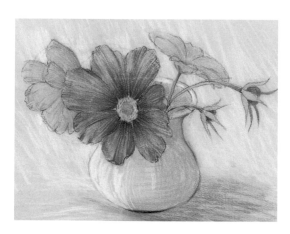

❺ Finished picture: Pastel paper, 21 x 28 cm (8 x 11 in). Add a shadow on the ground with charcoal, and pale blue over the top. Press hard the darkest parts of the petals with the dark pink. Scribble some white behind the pot and flowers to suggest a background. Spray the sketch with fixative.

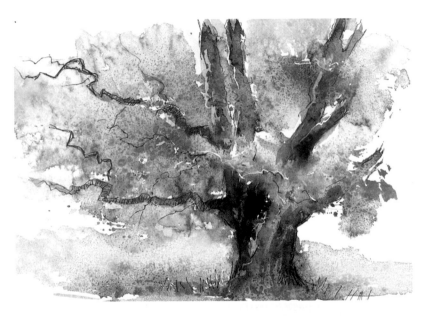

trees

To draw trees in all their forms and variety, you will have to understand their structure and be able to capture their essential shape as well as something of their life force. They all have the same basic structure, but they are often shaped by their experiences, and they have an individuality which makes every one quite different and unique.

Drawing trees

Trees are the very essence of the countryside. To make trees convincing, the basic structures of the trunk, branches, twigs, and leaf textures, and colours all need to be carefully studied. Observing a deciduous tree in winter is the easiest time, as they become quite daunting when clothed in a mass of foliage.

Basic steps

There are three main stages to drawing a tree successfully. First you will need to observe the outline, then the pattern and finally the structure.

Outline

Pattern

Structure

Start with the basic outline. Even within the same variety, trees tend to differ.

Look hard at the patterns within the tree: how do the lines within the tree flow?

Elaborate the structure by defining the areas of light and shade.

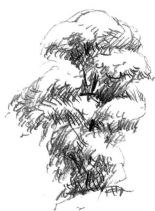

Tree trunk

It is fun to study trees. As well as having different shapes, their textures vary, too. A 4B pencil was used for these drawings. You can also try making sketches like these in conté and in pastel pencils.

 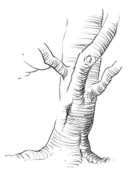 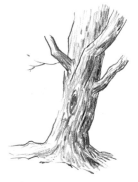

❶ Begin with a tree trunk. Notice how the tree flares out at the base, how the branches join the trunk, and that most branches stay the same width until they fork – they do not taper.

❷ Add curving lines running around the form. As you look up the tree, the curves arc upwards; looking down, the curves swing down. The lines curve under the branches, and dip into hollows.

❸ Suggest bark with parallel strokes, some light, some heavy. Heavier marks on the right of the trunk and under branches suggest round forms revealed by light from the left and above.

Tree bark

A tree's trunk is its protective armour. Tree trunks can be smooth, deeply fissured, metallic-surfaced, peeling in strips or thick and fibrous in texture. The amazing variety is quite breathtaking. Like the leaves, the trunk is characteristic of the variety of tree and needs careful observation.

▲ Sycamore: The lines and rectangles in the bark are detailed in assorted shapes and sizes using a black waterproof pen. This is covered by a grey and Violet watercolour wash.

▲ Scots pine: Brown, orange and yellow watercolours are painted in circles, ovals and blocks and diffused with a watersoluble pen in sepia. When dry, the definite shapes are detailed in with sepia.

▲ Silver birch: Watersoluble pencils create slender lines of yellow ochre, grey and browns to connect the abstract dark brown shapes. A wash is added to soften the contrasts.

Branches

A vital thing to notice about tree branches and twigs is that they do not actually taper. This is a common misconception. Look closely, and you will see that branches grow for a while and then throw off smaller branches, which, in turn, throw off even narrower twigs.

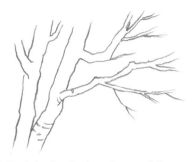

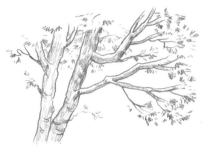

❶ Begin by drawing branches carefully, observing both the width of the branch, and the changes of contour and direction. Look at the shapes between the branches, this may help too. I sketched this in black conté.

❷ Now you can add leaves. You do not need to draw every leaf carefully – short, stabbing marks can be enough to suggest foliage. You could add the occasional proper leaf shape, since leaves vary from tree to tree.

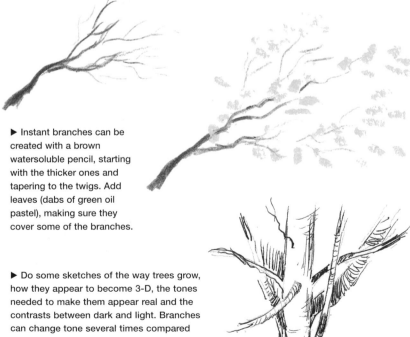

▶ Instant branches can be created with a brown watersoluble pencil, starting with the thicker ones and tapering to the twigs. Add leaves (dabs of green oil pastel), making sure they cover some of the branches.

▶ Do some sketches of the way trees grow, how they appear to become 3-D, the tones needed to make them appear real and the contrasts between dark and light. Branches can change tone several times compared with others in the background and foreground. A blue steel-nibbed pen was used here.

Leaves and fruit

Outdoor sketches of overall shape can be done quickly, but botanical examples allow leisurely study at home. Such details are unnecessary for painting a tree in its entirety but they give vital understanding of the subject.

❶ Draw outlines in colours that are characteristic of each set of berries, cones, buds and flowers. Notice how they compare with each other in scale.

❷ Infill the outlines, extending the colour range. This shows summer and autumn leaves on one twig, but ideally you should make separate seasonal studies.

❸ Complete the study by blending and overlaying with stronger colours. Be aware of tonal contrasts of light and dark, saving highlights from the start.

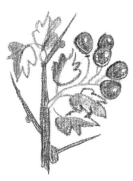

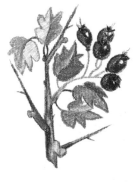

❶ Using the same method as above, draw details of a less densely foliaged tree, such as a hawthorn. Small, openly-spaced leaves on a twig indicate a tree that has only a light foliage canopy.

❷ Next you can lightly infill the leaves with some colour, reserving half of each. Next, infill the berries, too, but make sure that you save the highlights on them.

❸ Complete the infilling of the leaves, intensifying tonal contrasts. Strengthen the berries, being careful to preserve their highlights. Finally, you can add the long, spiny thorns.

Autumn leaves

Autumn brings new challenges for the artist. You will love painting the colours of this season: russet, oranges, reds, yellows and browns.

▲ Masking fluid is used for the pale veins and wet watersoluble pencils are mottled together for the leaf surface. Traditional yellow pastels are applied to show the drying leaf sections.

▲ The different parts of this leaf are sketched in dry watersoluble pencils, with small details in sepia waterproof pen. The violet, orange, pink and red are varied to contrast the different sections.

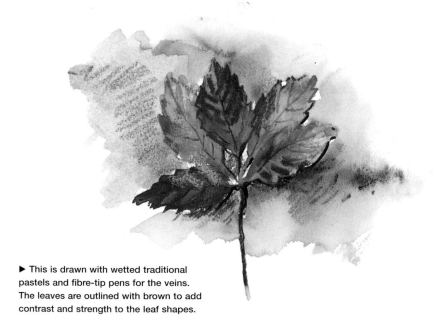

▶ This is drawn with wetted traditional pastels and fibre-tip pens for the veins. The leaves are outlined with brown to add contrast and strength to the leaf shapes.

Seasonal trees

Deciduous trees have a basic structure of a trunk, branches and twigs, which can be seen easily in winter. This is a very good time to study trees, and also to sketch lots of them in order to learn how they grow. When you do this, look hard at the tree you are sketching and don't generalize. Explore how the branches join trunks, and the twigs join branches.

Winter tree

Standing well back from a large tree, you can see the whole shape. Each different type of tree has a characteristic shape, so observe them carefully as they vary dramatically. Trees are as individual as people, so it would be wrong to generalize their shapes.

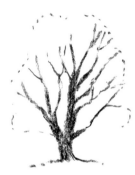

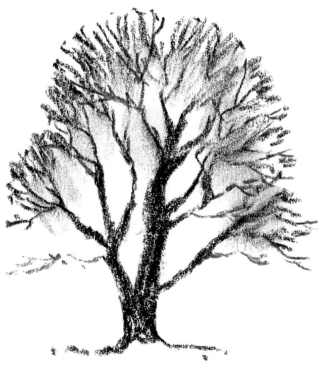

❶ With black conté or charcoal pencil, sketch the trunk and main branches. Half-close your eyes to simplify the tree's shape, and use dots to indicate the outer limits of this shape.

❷ Tiny strokes around the outer edge will suggest the mass of twigs, and gently softening with a finger gives the impression of fullness.

Summer tree

Trees in full foliage can be daunting to tackle — all those leaves — so we have to learn to simplify their shapes, to seek out the main masses or clumps of foliage, and find a suitable visual shorthand to use.

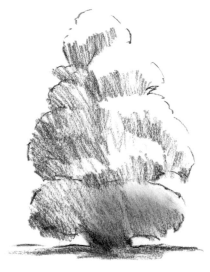

❶ Using a brown pastel pencil, begin with the main shape of the tree, making sure you 'plant' the tree in the ground.

❷ Simplify the tree into its main clumps of foliage. Look at the direction of the light – light from the sky and sun will provide shadow areas which you can define with simple parallel lines of shading. Add a shadow on the ground and soften the colour gently with a finger.

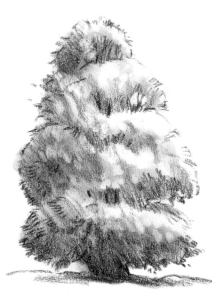

❸ Use a putty eraser to lift out some of the colour from the lighter areas, to give variations of tone in the foliage. Create some holes in the foliage, in order to see the sky behind. With your pencil, deepen the tone of the trunk, add branches in the sky holes and within the foliage, and use tiny dots and strokes to suggest leaves, and a filigree edge to the tree.

Seasonal foliage

In a temperate climate, the changing seasons bring with them dramatic changes in the trees, which have a wide range of different colours and textures at different stages through the year.

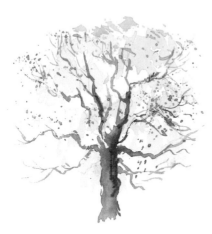

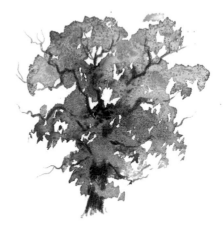

▲ Spring: The tree framework is painted in over a brief sketch, lightening the branches and thinning them with watery Raw Umber watercolour. Leaf Green is used for the leaves, and the colour is splattered on to show the fresh young foliage.

▲ Summer: The main trunk and some of the branches are drawn in sepia watersoluble pencil. The bulk of the foliage is painted in Olive Green and Cobalt Blue watercolours, with salt painted on while wet. When the paint is dried, this is brushed off and the remaining branches drawn in with pencil.

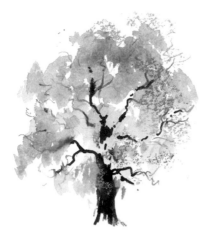

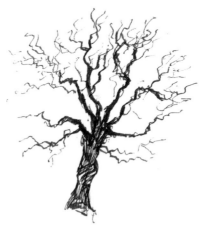

▲ Autumn: Orange and yellow washes are used over a framework of Raw Umber paint and pencils, leaving spaces for the bright foliage. When dried, add orange oil pastel. Keep some sky holes in the foliage.

▲ Winter: The skeletal shape is exposed. This time of year makes it easier to study the basic structure of a tree. Use a sketch of the sky shapes first to help with the whole effect. This is drawn with a sepia art pen.

 EXERCISE # Paint an autumn tree

Try copying this autumn tree, which uses salt for the foliage effect. Then find a similar one to try for yourself. Remember not to overwork your trees: you need only give an impression of the mass of foliage.

The palette Watercolours Waterproof pen

Neutral Cerulean Cadmium Cadmium Burnt Violet sepia
Grey Orange Yellow Sienna

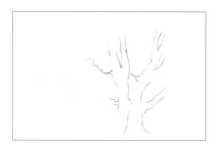

❶ Use a 2B pencil to establish the main shapes, noting any spaces between the branches (these give character) and comparing the length of the branches with the trunk to get the proportions correct.

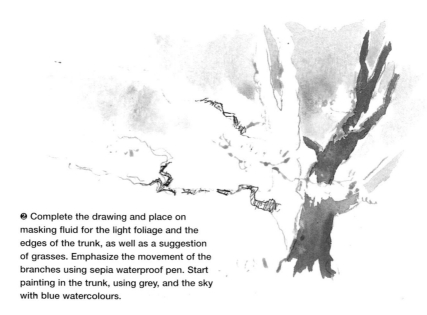

❷ Complete the drawing and place on masking fluid for the light foliage and the edges of the trunk, as well as a suggestion of grasses. Emphasize the movement of the branches using sepia waterproof pen. Start painting in the trunk, using grey, and the sky with blue watercolours.

TREES

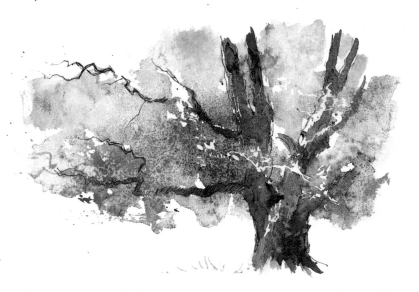

❸ Complete the trunk and add more branches in ink. Dampen the paper over the foliage area, apply a very watery wash of orange, yellow and brown, then sprinkle in table salt. When completely dry, rub off the salt and masking fluid.

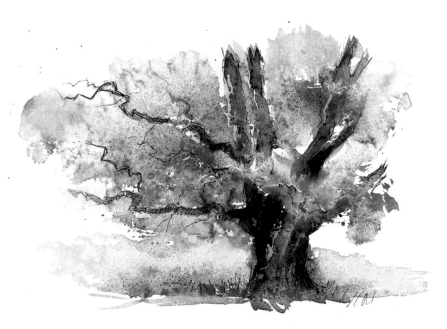

❹ Paint in the base of the tree trunk with brown, and then darken the trunk using Violet. Detail in more branches, this time using ink, and then gently soften the light areas of masking fluid with some pale yellow watercolour.

EXERCISE | # Sketch a tree in conté crayon

A simple image of a tree, with a rickety fence, makes an ideal sketching subject. The tree is the important part of this sketch: the fence is a fun extra.

The palette
Conté crayon

light pressure medium pressure firm pressure

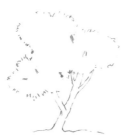 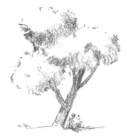 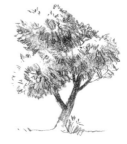

❶ Using black conté, firstly establish the main shape of the tree, and any branches that can be seen through gaps in the foliage. Look carefully to discover the direction of the light, and see if it reveals the main, large clumps of foliage.

❷ Block in the dark sides of the foliage with the side of the crayon. Bring the dark tone down onto the trunk. The tree will cast a shadow on the trunk; it is darker under the foliage than at its base. Suggest grasses with little strokes and dots.

❸ Find a shorthand for the leaves on the tree. Here, mostly short strokes, or little v-shapes have been used, with an occasional lozenge-shape. If you feel tentative, try out some marks on a spare sheet of paper before working on your tree.

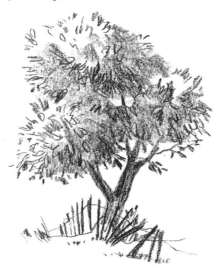

❹ Add in some leaf shapes, particularly around the edges of the tree. Look at mine on the right, and in the space in the fork of the tree. Actual leaf shapes will help to give the tree character, and the drawing credibility. Finally, you can draw in the old fence. This is easy and fun – just a few straight lines at different angles, joined up with a fine line.

Different trees

Trees present many different faces – bare branches, blossom, full leaf – and are always an interesting picture to capture. Keep things simple and see how individual trees vary, sometimes dramatically, in colour, tone and texture.

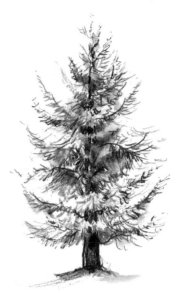

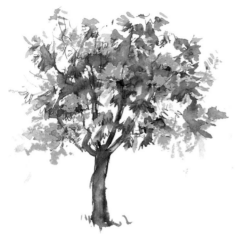

▲ This tree in blossom is painted using dabs of pink oil pastel for the blossoms, which act as a resist to the green and burnt sienna ink and watercolours in the leaves and branches.

▲ Here, blue and green watersoluble pencils with watersoluble sepia ink are feathered into graceful tapering shapes to create the upwards flowing foliage of a conifer.

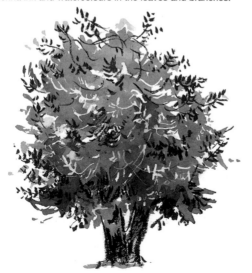

▲ The dense, spiky foliage of black ink and contrast of masking fluid details against the light green and Cerulean watercolour washes create this holly tree.

want to know **more?**

Take it to the next level...

Go to ...
▶ **sketch a lake scene** – page 132
▶ **planning landscapes** – page 138

Other sources
▶ **Photographs**
 useful sources of reference
▶ **Art shows**
 look out for local or national events
▶ **Sketchbooks**
 to record different tree shapes
▶ **Horticultural publications**
 for photographs and information on trees
▶ **Publications**
 visit www.collins.co.uk for Collins art books

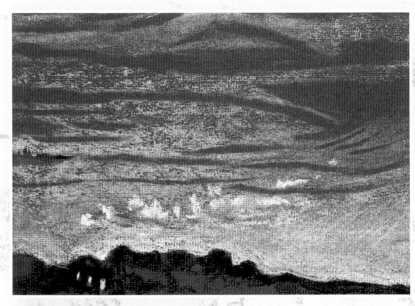

skies

The sky can be the subject of an image or it can support the rest of your drawing, always providing light, atmosphere and drama. The blue of the sky is both transparent and weightless, and you need to achieve a suggestion of three dimensions. Cloud formations vary dramatically, and are always on the move, so they require good observation.

Sketching skies

When you are working outdoors, the wind will blow things around, shadows will move and light will change. You will have to learn to work quickly. If you like the idea of a bit of practice before embarking on this adventure, try sketching skies from a window. This will teach you to work quickly, because clouds change shape in seconds. There are many different types of clouds, and it helps to know their types, but for the beginner, it's best to simply look hard and sketch what you see. Try using different media, until you find the one which suits you, and the subject, best.

Clouds in pencil

For sketching clouds, use your softest pencil – a 4B or even a 6B – which gives marks that are easier to erase than hard pencil lines.

❶ Quickly indicate the outline of the largest cloud you can see, pressing lightly and leaving lots of gaps.

❷ Assess where the light is coming from. Then, using the side of the lead, add some simplified shading to give the cloud 3-D form. You should try not to make your shapes too monotonously 'lumpy' or hard-edged – clouds are soft and wispy. Lift too-hard edges, or overworked areas, with a putty eraser.

Stormy clouds in charcoal

Charcoal is a superb medium for sketching storm clouds and skies. You can 'move it around' with your fingers and build up layers, or use it on its side to create the soft edges that are characteristic of clouds.

❶ Strictly speaking, you do not need to begin with an outline, but if you feel you need one, lightly start with the sharp point of the charcoal. Soften the marks with your finger if you wish.

❷ Switch to the side of the charcoal, using a fairly short piece, about 5 cm (2 in) long. Twist your wrist as you work, to suggest the curved undersides of the clouds in places, as shown here with the nearest cloud.

❸ Pressing harder with the charcoal still on its side, build up the layers of charcoal to suggest ominous black clouds. Soften some top edges with your finger, and sweep the charcoal across the paper to create the horizontal bases of the clouds. Finally, suggest some smaller clouds towards the horizon.

Sketching with watersoluble pencils

Here just three watersoluble pencils are used for the sky and fluffy cloud; blue-violet, cobalt blue, and turquoise-green, plus some clean water. Work on thick watercolour paper, because it will not buckle when water is added.

❶ Begin with the main outlines of the cloud formation, leaving gaps to suggest wispy edges.

turquoise-green blue-violet

cobalt blue

❷ Use parallel strokes of cobalt blue for the sky behind the cloud, and a little blue-violet within the cloud itself. Towards the horizon, add strokes of turquoise-green. Blue skies are usually a richer, darker blue above your head, and cooler, paler, and greener towards the horizon.

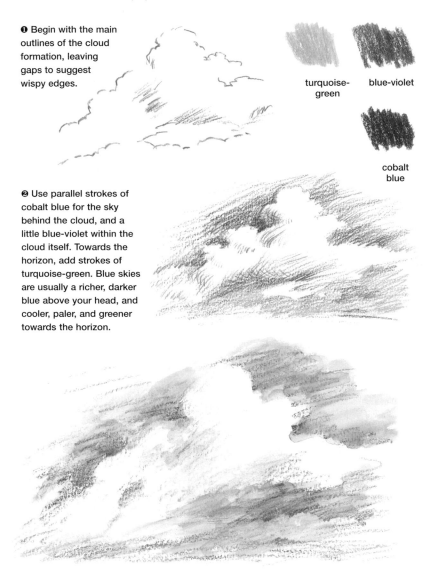

❸ As a sketch, it was complete enough at the last stage, but if you wish to exploit the watersoluble pencils to the full, loosen the colour with a brush and clean water. If you use plenty of water, the colour will float around and most of the lines will disappear. Any remaining lines give the impression of a blue sky you could fly through!

Creating colour effects

Skies and clouds aren't always blue and white. Different times of day and types of weather can create wonderful colour effects. For this warmer dusk sky, two very different types of materials are used. Never be afraid to mix your materials – anything goes to achieve the effect you desire.

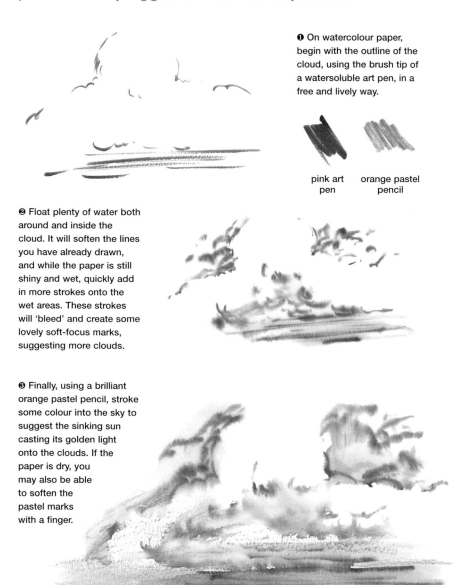

❶ On watercolour paper, begin with the outline of the cloud, using the brush tip of a watersoluble art pen, in a free and lively way.

pink art orange pastel
pen pencil

❷ Float plenty of water both around and inside the cloud. It will soften the lines you have already drawn, and while the paper is still shiny and wet, quickly add in more strokes onto the wet areas. These strokes will 'bleed' and create some lovely soft-focus marks, suggesting more clouds.

❸ Finally, using a brilliant orange pastel pencil, stroke some colour into the sky to suggest the sinking sun casting its golden light onto the clouds. If the paper is dry, you may also be able to soften the pastel marks with a finger.

A sky sketchbook

A sky is constantly in a state of change, so you are free to depict it in abstract shapes without fear of them being considered to be 'wrong'. Keeping a sky sketchbook will help you to handle pastels with confidence. Produce one study a day and note the time and date.

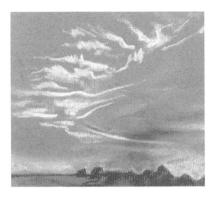

▲ This is one of a set of studies made early each morning from my bedroom window, using white and grey pastels and a sketchbook with paper of assorted colours.

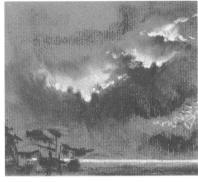

▲ Make a study at the same hour for three weeks. Select paper of a colour to match the general tone of the sky and use white for highlights and grey for darker tones.

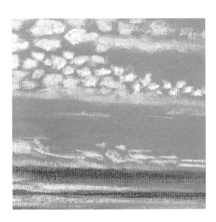

▲ After a few days, add a coloured pastel to the white and the grey. Lay the broadest bands of pastel first, finishing with the smaller details. Here pale blue was followed by grey and then white. While it is not an absolute rule, it is usually more effective to leave the white until last.

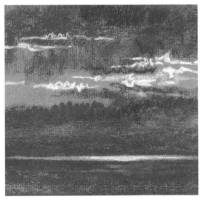

▲ In this sketch, grey was applied first, leaving a thin line at the horizon. It was followed by blue, yellow and white. You will not find drama in the sky every day, but low cloud cover will give you some practice in blending an even tone on the paper.

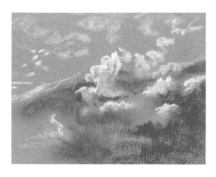

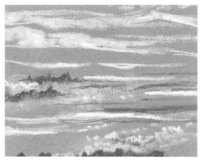

▲ Try making sky studies when you are on the move – watching skies from the windows of a train offers an excellent opportunity. Here white was applied before grey. They were blended together before further accents of white were added to the tops of clouds.

▶ When you return home from a journey, play with your studies. Experiment with reproducing the sketches using the same pastels but on papers of different tones and colours. You will find that you are able to change the mood of the subject.

▲ If you are tempted to record architectural or landscape features keep them simple and just add some written notes or you will become lost in detail. Dawn and dusk are good times for sky studies as the land is largely lost in the dim light.

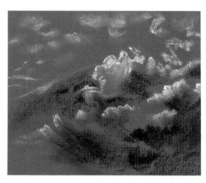

▼ Changing the background will also encourage you to explore different methods of creating the effects you want. Here, on dark-toned paper, streaks are lifted with an eraser instead of being drawn direct.

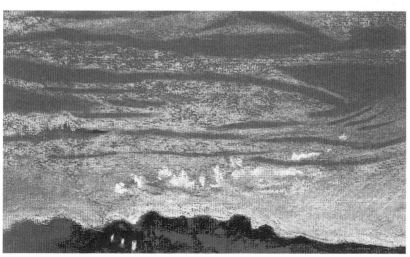

EXERCISE Clouds in charcoal and conté

You can choose a simple combination of black and white on a warm-coloured ground for a dramatic and effective sketch – proof that you don't always have to use blue for sky! Experiment with some different coloured backgrounds to produce varying effects.

The palette
Conté crayon

white conté crayon charcoal

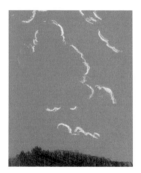

❶ On coloured paper – or white paper stained with a used teabag – use the side of a piece of charcoal to suggest a hillside with a few trees. Then position the clouds with the point of a white conté stick, or white pastel pencil.

❷ Using the side of the charcoal again, block in the darker parts of the clouds, to suggest their fullness. Use curving strokes to emphasize the form of the clouds.

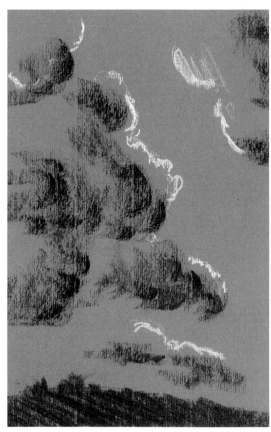

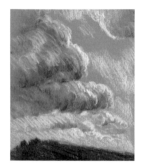

❸ Smooth some of the charcoal marks into the paper with your finger. Then you can begin to sketch in the lighter parts of the clouds with white, using some curving linear strokes, and following the form of the clouds. Use simple side strokes for the wispy clouds against the sky.

❹ Build up the forms of the clouds, using charcoal for the bottoms of the clouds, and marks in white for cloud tops and details. Where the white mixes with the charcoal, it forms a useful soft grey, which adds to the feeling of fullness. Press hard with your white for sharply lit edges. Spray fix the sketch.

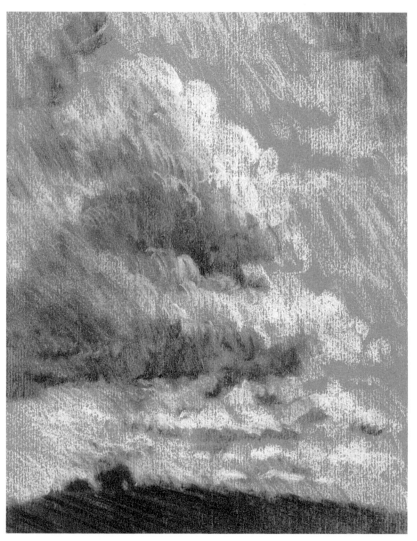

EXERCISE # Billowing clouds in pastels

Just six sticks of pastel were used for this sky scene, which captures the fluffiness of clouds and the blue bowl of the sky. Notice how the clouds diminish in size as they near the horizon; this gives a good feeling of space.

The palette
Pastels

| white | cream | light blue | blue | dark green | grey |

❶ Using the point of a dark green pastel, suggest the land. Using the sides of the pastels, block in the blue sky shapes, leaving spaces for the clouds. Blue sky is always cooler and lighter near the horizon. Blend the two blues with a finger, where they meet.

❷ Using a grey pastel, block in the darker sides of the clouds, to show their three-dimensional form. You could also use purple-grey, or even a grey-green, for this step – clouds are more interesting with a variety of colours in their depths.

❸ Using a cream pastel, and a light touch, stroke cream over the empty spaces, and over the grey, to create the main areas of fluffy cloud. Vary your pressure; a light touch will provide feathery edges. Gently blend with a finger in places. Stroke the side of the green pastel over the landscape.

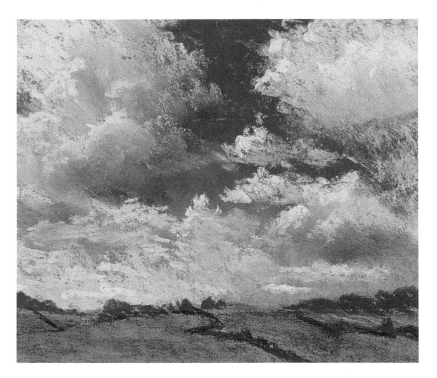

❹ Add more cream pastel, pressing hard for more solid areas in the mass of cloud, and stroking gently to create feathery cloud edges. Using the tip of a white pastel, press hard to define the sunlit edges of the clouds. Finally, add some tiny clouds near the horizon and using the dark grey pastel, add trees and shrubs to the landscape and gently blend the green with a finger for a slightly textured look.

MUST KNOW

Creating mood

Skies and cloud formations change constantly and what you choose to draw and how you do it will affect the mood of your sketch. You can opt for soft, subtle early morning skies, dramatic light effects with towering dark storm clouds and rain, or a gentle sunrise or sunset, which means that you can fun with coloured pencils or pastels.

want to know **more?**

Take it to the next level...

Go to ...
▶ **sketching water** – page 128
▶ **planning landscapes** – page 138
▶ **a beach walk in pastels** – page 182

Other sources
▶ **Photographs**
 useful sources of reference
▶ **Art shows**
 look out for local or national events
▶ **Art galleries**
 study how the old masters drew skies
▶ **Painting holidays**
 expand your horizons with other artists
▶ **Publications**
 visit www.collins.co.uk for Collins art books

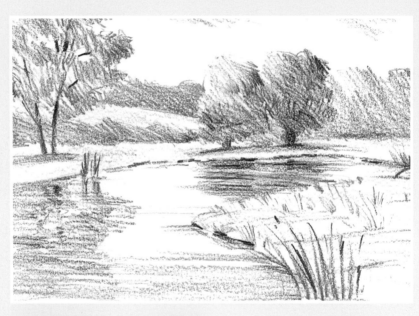

water

Water often reflects both sky and land, and reflections are transformed into fascinating abstract shapes by ripples and movement. Depicting water presents the artist with variety galore – whether it's still water, moving or falling water, clear or muddy water, waves, ripples or reflections. Indeed, it can provide us with inexhaustible diversity.

Sketching water

Since water is, basically, transparent, we are actually sketching surface reflections, rather than water itself. These reflections are constantly in motion, even in apparently still water, so we have to try our best to capture this movement. Once again, half-closing your eyes will help you to simplify what you see, and this is most important; you do not need to capture every ripple or eddy.

Still water

Begin these simple exercises with a stick of charcoal, choosing a fat piece which can be used on its side easily.

❶ Using the side of a piece of charcoal, make a few vertical overlapping strokes. As in the bottom half of the illustration, blend these strokes with your finger.

❷ Now for the magic part. Break off a small piece of putty eraser, and mould it to a point with your fingers. Stroke it horizontally across the charcoal, to give the impression of gentle surface movement. As you look across a stretch of water, these marks will gradually close up, giving the suggestion of space.

Reflections in calm water

Objects reflected in calm water can appear to be mirror images, but there are some slight differences which you need to observe carefully. Dark objects are always slightly lighter; light objects (including the sky) are very slightly darker. Tiny ripples will break up the reflections, leaving gaps.

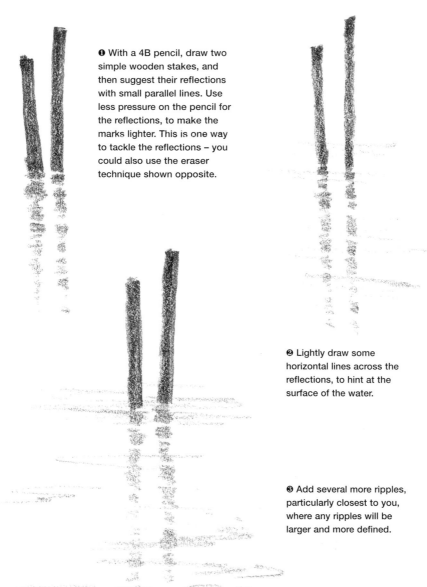

❶ With a 4B pencil, draw two simple wooden stakes, and then suggest their reflections with small parallel lines. Use less pressure on the pencil for the reflections, to make the marks lighter. This is one way to tackle the reflections – you could also use the eraser technique shown opposite.

❷ Lightly draw some horizontal lines across the reflections, to hint at the surface of the water.

❸ Add several more ripples, particularly closest to you, where any ripples will be larger and more defined.

Moving water

Wind will disturb the surface of pond and lake water, creating waves, and water will create patterns as it runs along. Rocks in the path of moving water will force the water to swirl around them. Before sketching moving water, spend time simply watching and analysing what you see.

❶ Using a pale turquoise and a bright blue pencil, draw a series of shallow, curved lines, allowing some of them to meet in little inverted v-shapes to suggest the wave tops.

pale turquoise bright blue dark green

❷ Now sketch in the right-hand sides of the waves, using firm strokes of blue and dark green. Leave the paler colour to 'read' as light on the surface from the left. Make the waves bigger close to you.

❶ Using a conté pencil, begin by drawing a chunky rock, using small vertical strokes to suggest its surface. Place a few tiny horizontal curving lines for the moving water.

❷ Build up the ripples around the rock, using close lines underneath the rock to suggest a broken reflection. Flick the lines on with swift movements of the pencil; do not labour the strokes or you will lose the sense of movement.

Waterfall

To capture the sight of water rushing headlong over a waterfall, the white of the paper can be left to read as foam. An alternative approach would be to work on a coloured ground, using white conté, or pastel pencil, for the foam.

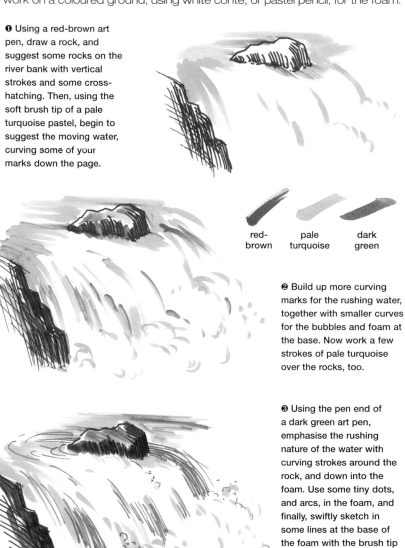

❶ Using a red-brown art pen, draw a rock, and suggest some rocks on the river bank with vertical strokes and some cross-hatching. Then, using the soft brush tip of a pale turquoise pastel, begin to suggest the moving water, curving some of your marks down the page.

red-brown pale turquoise dark green

❷ Build up more curving marks for the rushing water, together with smaller curves for the bubbles and foam at the base. Now work a few strokes of pale turquoise over the rocks, too.

❸ Using the pen end of a dark green art pen, emphasise the rushing nature of the water with curving strokes around the rock, and down into the foam. Use some tiny dots, and arcs, in the foam, and finally, swiftly sketch in some lines at the base of the foam with the brush tip to show fast-moving water.

EXERCISE A lake scene in coloured pencils

Just four coloured pencils were used for this simple lake scene, which is an opportunity to practise sketching trees and water. Try a similar sketch from life for yourself: just four pencils and some paper are easy to carry!

The palette
Coloured pencils

gold-yellow

cobalt blue

bottle-green

dark blue

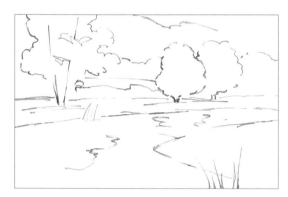

❶ With an HB pencil, lightly 'rough in' in the main elements. Lift the pencil marks slightly with a putty eraser once you are happy with the composition.

❷ Begin with the lightest colour, a gold-yellow, and using parallel shading strokes, work across the trees, bank and land. Begin to add bottle-green.

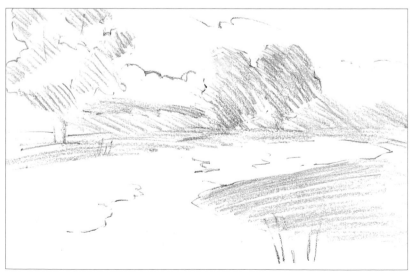

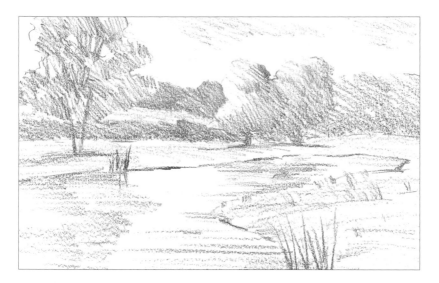

❸ Use bottle-green for the bushes and trees, the reeds by the water, and the trees' shadows. Press hard here and there to emphasise the bank of the lake, and draw parallel horizontal lines in the water to suggest the trees' reflections. Use cobalt blue for the sky and horizontal lines on the water, reflecting the sky.

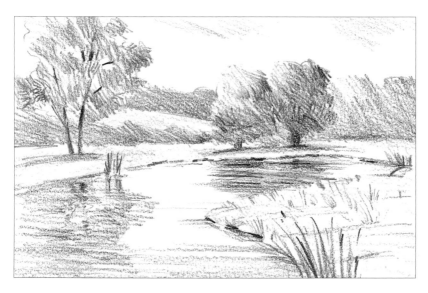

❹ Using a dark blue, and short linear strokes, darken the shadow sides of the trees on the right, the trunk and branches of the left-hand tree, and then darken the tree reflections in the water. Short strokes will emphasize the near bank and bring it forward. Finally, add a few dark reeds to finish the picture.

EXERCISE Sketch a waterfall in pastels

A tumbling waterfall is an appealing subject, and this one creates a lovely shape on the paper. Always squint at your subject – it simplifies the shapes.

The palette

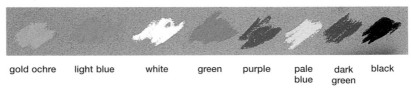

gold ochre light blue white green purple pale blue dark green black

❶ You can create an arrangement of almost abstract shapes on the paper, using charcoal to define the rock areas, leaving the paper untouched for the water area. Block in the shapes with the charcoal, and then smudge a little with a tissue to soften any hard lines and blend the charcoal, as shown on the right of the picture.

❷ With your darkest pastels, block in the colours loosely, using the side of the pastel. The colours can be placed in quite a random way, as you are simply creating an 'underpainting'. Blend the colours, in places, with a finger, and leave other areas unblended to suggest texture.

❸ Add in some dark, rich purple to give some warmth and variety to the rocks, and then, using pale blue, use directional strokes for the water, following its path. If you look closely at the passages of water, you will be able to see the direction of the strokes.

❹ Suggest sunlight on the rocks with a gold ochre pastel; the sunlight on the water is created with white. Add medium blue linear strokes to the water at the foot of the falls and 'scumble' touches of all the medium tones lightly over the rocks to suggest lichen and texture.

want to know **more?**

Take it to the next level...

Go to ...
▶ **Seaside sketching** – page 178
▶ **A beach walk in pastel** – page 182
▶ **Seascape in watercolour** – page 186

Other sources
▶ **Photographs**
 useful sources of reference
▶ **Art shows**
 look at subjects and composition
▶ **Trips to the seaside or country**
 sketch any water subjects you see
▶ **Painting holidays**
 expand your horizons with other artists
▶ **Publications**
 visit www.collins.co.uk for Collins art books

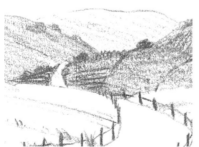

landscapes

A good landscape requires a mastery of so many elements: drawing, tone, colour, texture, form, space and atmosphere. If you are to become a good landscape artist, you need to be prepared to spend some time sketching outdoors. You will experience a wide range of changing light effects and the sheer joy and exhilaration of drawing and sketching.

Planning landscapes

In general, when tackling a landscape, it's a good plan to consider three main areas – foreground, middle distance, and distance. If you handle these areas successfully, the viewer's eye will move back through the picture, as if walking through the landscape to the distance beyond.

Distance

To achieve a real sense of depth in a landscape sketch, you will need to consider two things. Firstly, the further away, the paler things become. This is called 'atmospheric perspective'. Secondly, the further away they are, the smaller things become. This is an enormous simplification, but you will be successful if you observe, measure, and try to reproduce tones faithfully. It will teach you a great deal if you work in monochrome to begin with.

▶ This pencil sketch of a mountain range shows how distance is implied by very pale tones furthest away, and strongest tones in the foreground. Atmospheric perspective interferes with vision, making tones lighter, less contrasting and bluer, which is why far-distant trees, hills and buildings always appear to be similar in tone, and rather blue.

▼ This pencil sketch shows clearly that objects close to you appear to be much larger than those far away. The rocks and grasses are far bigger than the trees in the distance, and yet we know, intellectually, this cannot be the case. Always measure to double-check sizes of objects and spaces in a landscape picture.

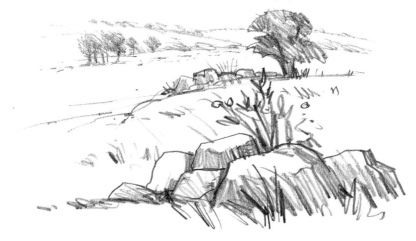

Creating depth

This little example shows how to create a sense of depth in a sketch. Use a coloured pencil – any colour will do. If you decide to work from a photo of your own, do be careful – photos can sometimes fail to capture the subtle tones in the distance. Lighten the distance if you need to.

❶ Begin with the main outlines in the landscape, measuring the sizes of the shapes that you can see. Landscape will constantly surprise you; distant fields are often far smaller than you would think. Try to make good use of overlapping forms like these, they help to suggest space.

❷ Lightly add shading over all of the distant hills, using the same tone throughout. Use a few parallel lines on the foreground.

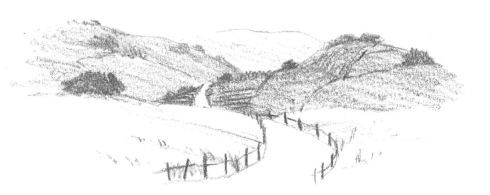

❸ Build up the tone of the second and third 'hills', increasing the strength of tone gradually. Finally, draw in the details on the landscape, ensuring that the trees are larger on the nearer hill, and smaller further away. Flick in some tiny grasses in the foreground. Notice that these marks are bigger than the distant trees.

Foreground

If your sketch is to include foreground, middle distance, and far distance, then a very busy foreground may prevent the eye from moving back into the picture. The problem is that the foreground will dominate our vision because it is so close to us, and the temptation to include too much is very strong. We have to learn to use what we see very selectively. Here are a few clues to the successful use of foreground features.

► Putting roads, pathways, and river banks in the foreground will lead the eye of the viewer from the edge of the picture into the middle or far distance.

◄ If there is no obvious path or edge to lead us in, we can use marks to suggest the ground surface. Here, grasses, some tall enough to link foreground and background, have been used, but on a beach, for instance, it could be sand humps or pebbles. If it was water, it could be ripples.

► Shadows can be very useful in a picture: here they break up a flat foreground area and lead the viewer's eye back to the trees.

❶ Using a coloured pencil, begin with the main large landscape elements in the distance, leaving space at the base for the foreground. Tiny parallel strokes depict grass in the middle distance.

❷ Remember, the closer to you, the bigger the objects – here the grasses and wild flowers are taller than the distant trees. Use parallel strokes, dots and dashes for the grasses, and little zig-zag shapes for leaves and petals. In the foreground, contrasts are strongest. Press hard for some dark marks to contrast strongly with the white paper.

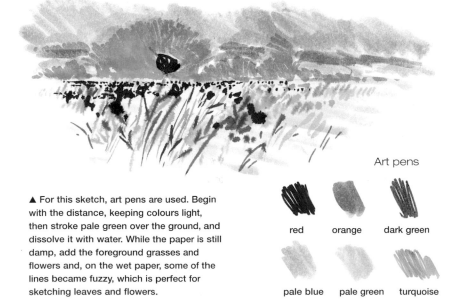

▲ For this sketch, art pens are used. Begin with the distance, keeping colours light, then stroke pale green over the ground, and dissolve it with water. While the paper is still damp, add the foreground grasses and flowers and, on the wet paper, some of the lines became fuzzy, which is perfect for sketching leaves and flowers.

Art pens

red orange dark green

pale blue pale green turquoise

EXERCISE ## Middle distance in mixed media

This little sketch, which is only 23 x 18 cm (9 x 7 in), was created quite quickly, using watersoluble felt pens and just a few soft pastels. Like most garden scenes, it shows both the foreground and middle distance.

The palette Watersoluble felt pens

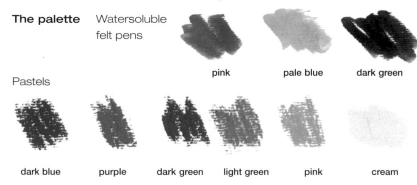

pink pale blue dark green

Pastels

dark blue purple dark green light green pink cream

LANDSCAPES

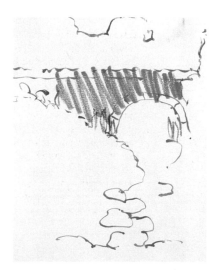

❶ With a pink watersoluble felt pen, sketch in the outline of the bridge and also the dry stream bed. Suggest some foliage, and the trees behind, with a blue felt pen. Begin to block in the colour shapes quite loosely.

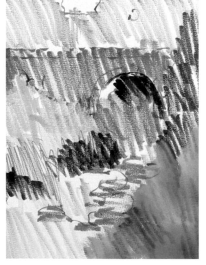

❷ Continue to block in colours, bringing in some darker areas with a dark green felt pen. When all the shapes are blocked in, begin to dissolve the marks with a just-wet paintbrush and some clear water. Do not worry if the colours run into each other.

❸ Allow the sheet to dry and then, using a pink pastel, a purple, a dark blue, and two different greens, work over the watercolour base, using both side strokes, and linear marks to suggest foliage.

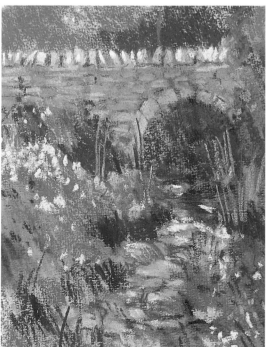

❹ Now bring in the lightest cream pastel and, with some linear dots and dashes, add tiny wild flowers; lighten the top of the bridge and also some of the stones in the foreground, and then use the point of the purple pastel to pick out small dark details. Build up the foliage area and add long linear strokes, both dark and light, to suggest the tall grasses and reeds.

EXERCISE Distant landscape in pastels

Distance in a landscape is usually achieved with change of scale, cooler colour and lighter tones. Often, distant hills are seen to be the most delicious blue-purple, their local colour filtered and softened by the veils of atmosphere between us and the distance.

The palette
Pastels

cream dark green light green light brown

turquoise medium purple blue white pale blue
 blue green

❶ On a soft brown sheet of pastel paper, draw in the main shapes of the landscape, using a blue pastel pencil, which will blend well with subsequent applications of colour. There is no need for detail at this stage – the main shapes will be sufficient.

❷ Using a fairly light touch, begin to block in colour, using the sides of the pastels. Use pale blue and cream for the sky; purple blue and pale blue for the distant hills, cool medium blue green for the nearer hill and some of the tree shapes, turquoise for the middle distance fields and a soft light brown for the foreground.

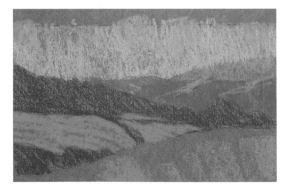

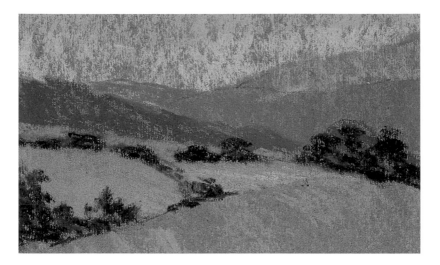

❸ Using a the darkest green, use short linear strokes, with the tip of the pastel, to create the trees and hedges, varying the scale, and the shapes. Notice how tiny touches for hedges and tiny shapes for fields will emphasize the sense of space in your drawing. Now begin to introduce some long strokes of warm light green into the foreground field in order to suggest the presence of grasses.

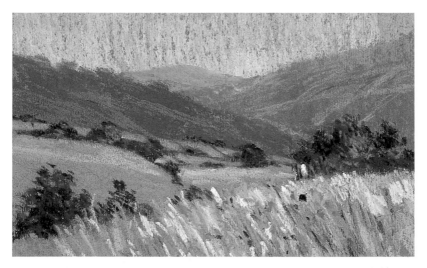

❹ Use tiny touches to describe the trees and vary the tone with subtle touches of medium green to suggest light on the foliage. Use cream and dark green linear strokes for long grasses in the foreground. Stroke lighter tones – cream and green – over the fields in the middle distance, pressing hard for more positive colour, and stroke the side of the cream pastel gently over the sky, to create a visual blend. Dots and dashes of both blues in the foreground suggest wild flowers – the finishing touch.

EXERCISE # Landscape in pastel pencils

Often, by copying another artist's work, we can learn a great deal which we can then use at a later date. Do not worry if your colours differ; just work through the steps – you will learn much along the way.

The palette

Pastel pencils

dark blue pale orange pale green pale blue

brown dark grey pale golden- dark green grey-green pale blue
 yellow

❶ Working on a sheet of cream-coloured watercolour paper, you can lightly sketch in the main elements of the landscape, using an HB pencil. You could work directly with the point of an art pen, but you will find that pencil is easier to correct.

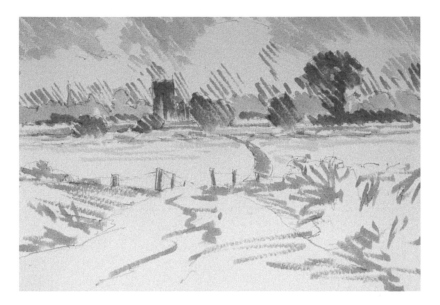

❷ Using the brush tip of a pale blue art pen, roughly block in the sky, and distant trees, and a few horizontal lines in the distant field.

Using a pale orange pen, add some lines behind the trees, and swiftly suggest the rough foliage in the foreground and the track.

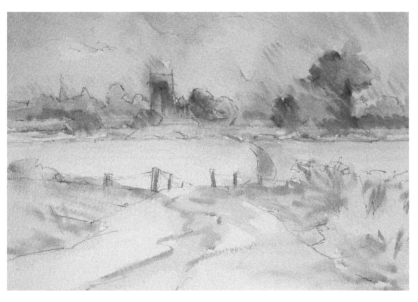

❸ Now load a brush with some clean water, and literally float the water over your picture. You will see that the lines of ink dissolve, leaving you with a lovely atmospheric 'under-painting' on which you can finish off your sketch.

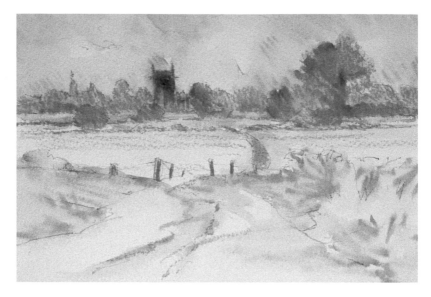

❹ When the picture is completely dry, use small strokes of a pale blue pastel pencil for the distance. Do not press too hard – the the texture of the paper will break up the marks. Very lightly stroke a few horizontal lines over the distant field.

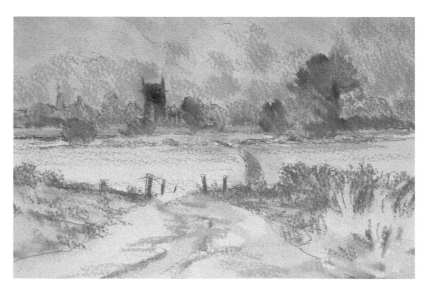

❺ With a pale golden-yellow pastel pencil, work on the clouds behind the church, the ground under the church, and in front of the distant trees. With a soft grey-green, suggest the foreground hedgerow and grasses with little scribbles.

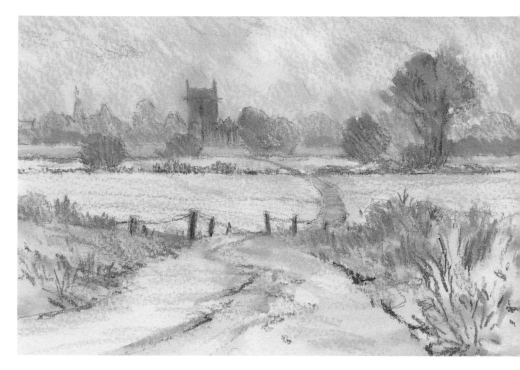

❺ Finished picture: Tinted watercolour paper, 18 x 25 cm (7 x 10 in). Finishing off is enjoyable, but it is easy to overdo final touches. Using a dark green, define the hedgerow a little more, with small, flicky marks. Switch to brown, and add more grasses, and go over some of the nearer trees and shrubs. Soften the colour in the clouds with more pale golden-yellow and use this colour over the road, both in the foreground and the middle distance. Finally, with dark grey, sharpen up a few foreground details – in the road, and on the fenceposts. Stop if you think you are fiddling.

Detail: This area of the picture shows how well the strokes of pastel work over the pen brush strokes.

want to know more?

Take it to the next level...

Go to ...
▶ **sketching water** – page 128
▶ **sketch a street scene** – page 172
▶ **seaside sketching** – page 178

Other sources
▶ **Photographs**
 useful sources of reference
▶ **Art galleries**
 look at others painters' work
▶ **Sketchbooks**
 keep a record of what you see
▶ **Painting holidays**
 expand your horizons with other artists
▶ **Publications**
 visit <u>www.collins.co.uk</u> for Collins art books

people and

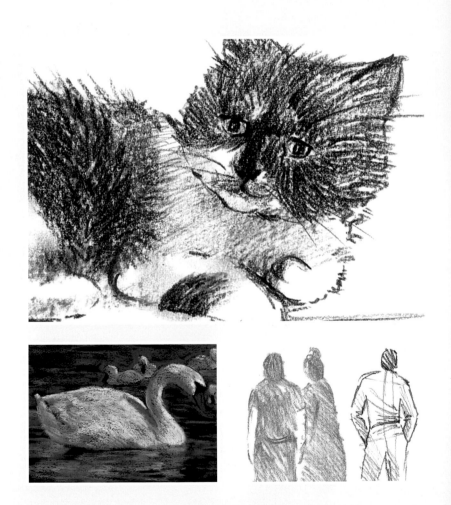

animals

The human figure has inspired artists ever since man began to paint on cave walls. The appeal of the human form is limitless – no matter how small a figure in a scene, it will attract attention before any other element. Animals can also add a touch of life to a sketch, and many artists find them engaging and rewarding subjects in their own right.

Sketching people

Figures can make or mar a picture. You may be able to distort a tree slightly and get away with it, but a distorted figure will look all wrong. This section is about ways to draw figures quickly and convincingly, so that you can include them in your sketches. Carry a pocket sketchbook, and practise whenever you can – in the library, while you wait at stations or airports or in cafés.

Simple figure

When drawing a single figure, you may have time to concentrate on the proportions. If these are right, the figure will look convincing. In a quick sketch, don't worry about details such as hands or feet – go for the shape.

▲ Pretend your figure isn't human and draw it as you would a bottle, thinking about the shape and the outline. The head becomes the stopper on the bottle, and the arms and legs simply part of the body of the bottle.

▲ If the figure is leaning, draw the head and a line for the feet. Draw a line from the head down the body, to show the direction of the spine. Add lines for the shoulders and hips, looking at the angle.

▶ Make the heads of your figures smaller than you think they are. A too-large head will make your figure look like a tall child, or a figure with a balloon-like head.

Multiple figures

Groups of figures present a challenge, but a simple large shape, with a few carefully-placed heads, and a few legs, will often give the impression of a group, without you having to add too many details!

▶ Where two figures are side by side, squint to see the shape they make together, and draw that shape. Then add just enough details to show that there are two figures.

Spanish lady

This woman is standing by her doorway. Always try to put some of the surroundings into a figure sketch. They will provide scale and a location for your figure. A little sketch like this might be useful in a future painting.

❶ Begin sketching in pencil with the main shape of the figure, the stance of the legs if they are in an unusual position, and a few lines for the doorway.

❷ Add in more detail – the position of the arms, eyes, nose and mouth. This isn't strictly necessary, but it is helpful to hint at features if a figure is facing you.

❸ Use coloured pencils to complete the sketch: brown for the skirt and doorway, and also to darken the legs under the skirt. Add a shadow on the ground.

Drawing after Dégas

Copying an old master's work is an excellent way to learn – one that is used by many an art student at college. One of Dégas's dancer drawings is recreated here, with just four sticks of conté crayon.

❷ You must study the original drawing carefully, and strengthen the line work, to include any areas of shadow/tone. Notice how Dégas anchored his figure to the ground with the shadows, so that the figure does not float in space. Try to make your lines follow the form – round the arm muscles, down the skirt, hair, and back leg.

❶ Copy the main lines, being very careful with the proportions. If you feel unsure about your ability to copy accurately, it is acceptable to enlarge the original and then trace the outline, but in your sketch try to keep your line work sensitive: light in places and heavier in shadow areas.

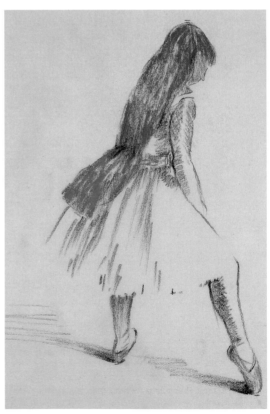

❸ Although the original drawing had black hair, use some red conté to contrast strongly with the blue bow at the back of the dress. This is a device Dégas often used. Gently apply the red conté to the skin, but press firmly for the hair. Add strokes of blue to the bow.

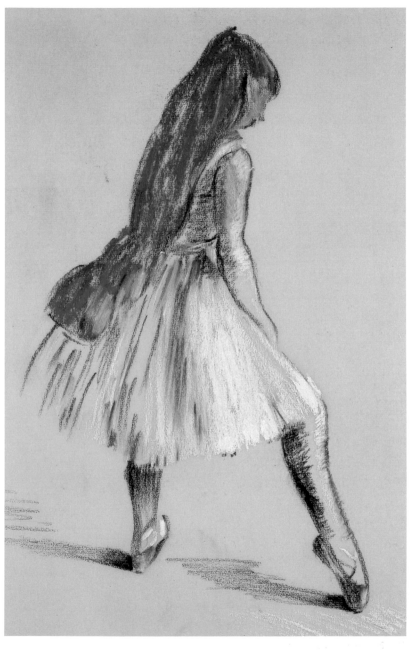

❹ Complete the drawing with white conté. Stroked gently over the red conté, it will give a pink skin tone. Press hard for highlights. Use long vertical strokes of white for the dress. Use short horizontal marks down the front of the leg, and add touches of white to the blue bow – it will blend with the blue. Finally, a few strokes of white on the floor.

Sketching animals

A few sheep or cows in a landscape, or a cat in a garden, can add life and interest to a scene, so practise sketching animals whenever you can. Be prepared for the fact that animals always move when you don't want them to – if this worries you, find sleeping creatures to sketch! Use a big sheet of paper, and if your model moves, sketch another pose; when it moves again, start another. Fill the sheet with sketches, and gradually you will learn the animal's shape.

Sheep and cows

Try to simplify the shape of the animal as quickly as possible, perhaps with a basic geometric shape, and complete as much of the pose as you can. Even if the animal moves, the chances are that it will return to that pose, and you can add more details gradually.

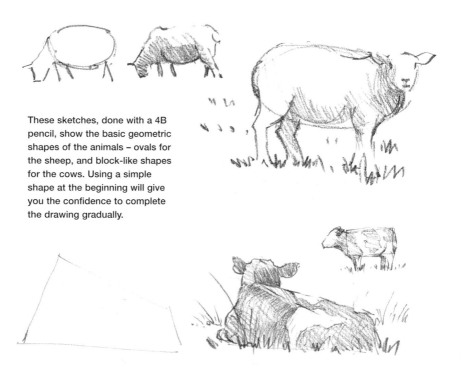

These sketches, done with a 4B pencil, show the basic geometric shapes of the animals – ovals for the sheep, and block-like shapes for the cows. Using a simple shape at the beginning will give you the confidence to complete the drawing gradually.

Tortoiseshell kitten

When they have finished tearing about at top speed, kittens will collapse and sit still for quite a long time. They are lovely subjects for sketching. When they are tiny, their heads seem to be too big for their little bodies.

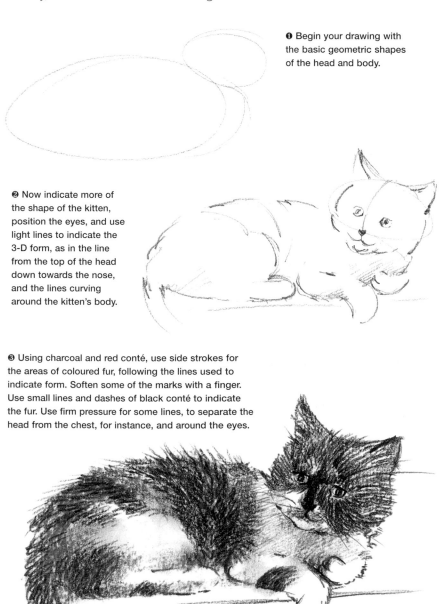

❶ Begin your drawing with the basic geometric shapes of the head and body.

❷ Now indicate more of the shape of the kitten, position the eyes, and use light lines to indicate the 3-D form, as in the line from the top of the head down towards the nose, and the lines curving around the kitten's body.

❸ Using charcoal and red conté, use side strokes for the areas of coloured fur, following the lines used to indicate form. Soften some of the marks with a finger. Use small lines and dashes of black conté to indicate the fur. Use firm pressure for some lines, to separate the head from the chest, for instance, and around the eyes.

EXERCISE # Swan & cygnets on black paper

Brightly-coloured pastel will 'glow' on any dark paper, especially black. You can use either soft pastels or hard sticks, but don't use pastel pencils. Sketching from a photograph is perfectly acceptable, but you should also spend some time sketching birds and animals from life.

The palette Pastels

| pale blue | dark blue | medium blue | green | pink | orange | grey | red | white |

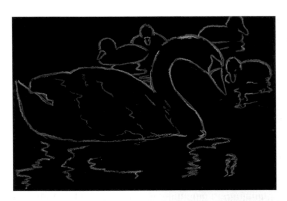

❶ Draw the main outlines of your subject onto the black paper, using a light-coloured pastel – pale blue or even white will do. The outline can be quite positive, since it will be obscured eventually by subsequent pastel layers.

❷ Roughly block in some of the colours, using medium tones of blue for the swan and purple-pink for the cygnets, with some touches of pale blue on top. This is, in effect, an 'underpainting', as you are working from dark to light and you will layer light tones on top in due course.

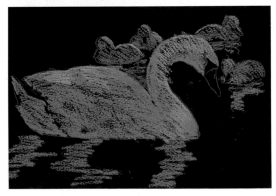

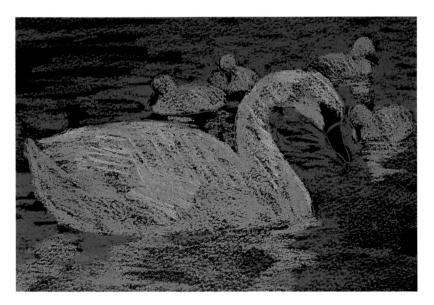

❸ Using a slightly darker blue, suggest the surface of the water with some horizontal strokes. Work on the cygnets, adding some lighter blue to the pink – cygnets are a pinky-grey colour. At this point, you should lightly spray the picture with some fixative. It will help to keep the lighter layers from mixing with the darker ones.

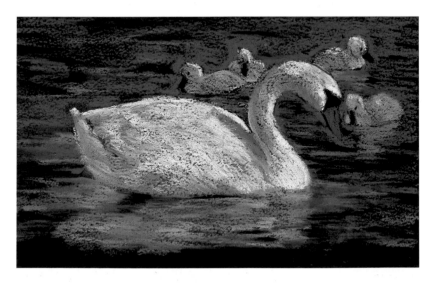

❹ Now you can enjoy adding the lighter tones, colour mixing by building one colour over another with small cross-hatched lines to achieve the tone you want. The cygnets, for example, are a mixture of pink, blue and tiny touches of orange. The head of the swan is touched with orange, and there are pinks and blues in the shadows, and white for the sunlit feathers. Finally, add dark blue and touches of green to the water.

EXERCISE Sketch a boy and his dog

As both people and animals move about so much, try to develop 'speed sketches', capturing main shapes and not including fiddly details. If you copy this exercise or work from a photo, set a timer for, say, five minutes maximum, and try to work much faster than usual. This will force you to simplify.

The palette
3B pencil

 light tone medium tone dark tone

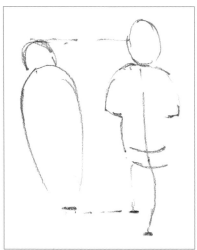

❶ Using a 3B pencil, start off your drawing by quickly capturing the main shapes of your subject. Before continuing, check the proportions carefully. You can see that this little chap's head 'goes' four times into his body (most adults are about seven 'heads' high). Unlike adults, children's heads are relatively big in relation to their bodies.

❷ Now define the outline of the figure more carefully. A line indicates the centre back of the head, to show that it curves, and turns a little. We look down to see a child, so the base of the T-shirt, the sleeves and the shorts arc downwards. However, on the back leg, which is lifting towards us, the lines arc upwards.

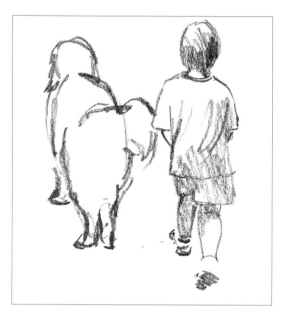

❸ Refine the shape of the dog, and add some tone on the figure to explain the light from above. Sketching the feet can be difficult, particularly when a figure is walking or running, but just a few lines to hint at the feet may be enough.

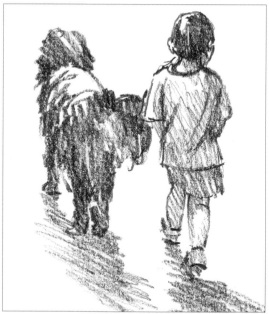

❹ Scribble is used for the shaggy dog, leaving a light area across its back to suggest form. Add more shading to the boy leaving light patches on the shoulder and back calf; add shadows on the ground, then stop or you'll overdo it.

want to know more?

Take it to the next level...

Go to ...
▶ **sketch a street scene** – page 172
▶ **beach walk in pastel pencils** – page 182

Other sources
▶ **Photographs**
 useful sources of reference
▶ **Art galleries**
 look at portraits and pictures of animals
▶ **Sketchbooks**
 record your observations
▶ **Life classes**
 find out if there are any in your area
▶ **Publications**
 visit www.collins.co.uk for Collins art books

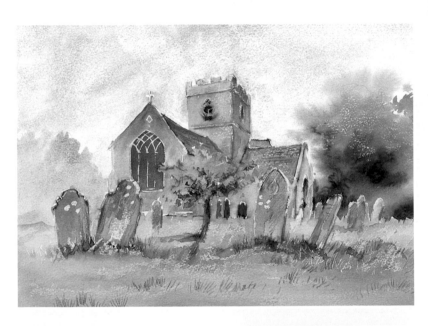

buildings

To draw a building properly, you need an understanding of the rules of perspective and how to measure proportions. The good news is that once you have learned the simple basics of perspective and can measure accurately, you can solve any problems quickly and easily, and your sketches will have strength and authority.

Sketching buildings

Buildings, like people, need to be drawn accurately or your sketch will look very poor. Sketching buildings means tackling that supposedly frightening subject – perspective. Perspective need not be terrifying, however, provided that you take on board just a few simple principles.

Basic rules

You learnt how to measure proportions on page 70. When you are using artists' measuring, do not forget to lock that elbow!

▶ Horizontal and vertical lines in architecture are simple to draw, as in this window. You need only concern yourself with the proportions.

▼ When parallel lines (the top and bottom of a window like this, or a road or wall) recede away from you, they create angles. If you keep extending these lines, they would meet eventually at a 'vanishing point'.

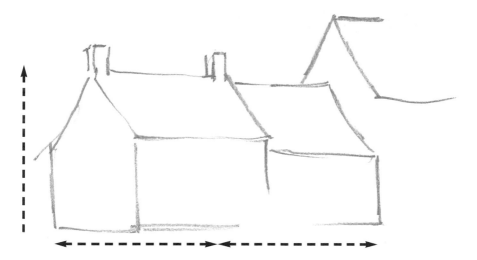

▲ Firstly, draw what you see – then check proportions. Never begin with the rules and then try to make the drawing fit; this is a common mistake. Draw freehand, trusting your eye. Then, and only then, use the perspective 'rules' to check your drawing's accuracy. Establish that the proportions of your buildings are correct. Always start with the largest proportions, and work down to the smaller ones, such as windows and doors. In this sketch, the height of the buildings 'goes' twice into the width.

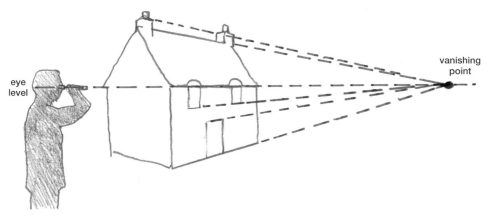

eye level

vanishing point

▲ Once the proportions are correct, you need to check any angles, and to do this, you need to establish your eye level in the scene. Place your sketchbook on the bridge of your nose and then look across it at the scene. That will be your eye level. Now mark your eye level on your sketch. You must ensure that all the receding lines above your eye level travel down towards the eye level, and all the receding lines below your eye level travel up to it. These lines should meet at a vanishing point, which can sometimes be off the paper or the sketchbook page.

Checking angles

Even if your angles meet nicely at a vanishing point, you may have misjudged them and made them too steep or too shallow. An excellent way to check is with an angle gauge, which you can make from two pieces of card held together with a mushroom staple.

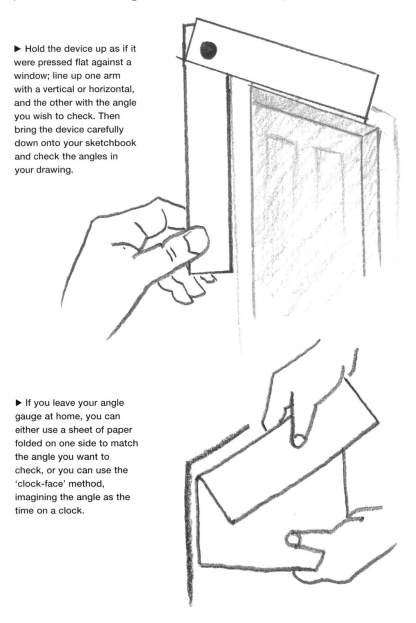

▶ Hold the device up as if it were pressed flat against a window; line up one arm with a vertical or horizontal, and the other with the angle you wish to check. Then bring the device carefully down onto your sketchbook and check the angles in your drawing.

▶ If you leave your angle gauge at home, you can either use a sheet of paper folded on one side to match the angle you want to check, or you can use the 'clock-face' method, imagining the angle as the time on a clock.

The shape of the sky

When you tackle a whole row of buildings, or a street scene, it can be quite difficult to simplify the mass of buildings that you see, and to get the silhouette right. Try looking at the shape of the sky to help you.

▲ 'Seeing' the sky as a simple light shape against the rooftops is a helpful way to begin your sketch, instead of starting with the complexity of the buildings.

▶ When you are satisfied with the shape of the skyline, then you can use the corners of the outline to drop down vertical lines, which will create the edges of the buildings. Then it is much easier to position the doors and windows.

MUST KNOW

Measuring

Without really accurate proportions, a building will not only look wrong or distorted, but also the windows and doors simply will not 'fit'. It is always a good idea to measure the largest proportions first – the height and width of a building – before dealing with the details.

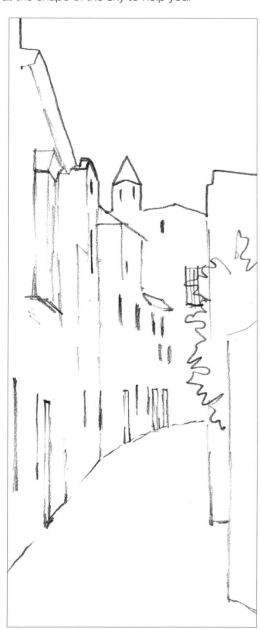

Windows and doorways

Look at the features of a building: doors and windows. You need to be accurate when you portray a window's construction and shape, but your painting can be looser and more interesting if you add details like curtains.

❶ Draw in the main details. Apply masking fluid to the net curtain details, and then you can start painting in the surrounding brickwork.

❷ Paint in the window area, using a mixture of brown and dark blue watercolour. Place in the bricks with some orange oil pastels.

Watercolours

Alizarin Crimson

Burnt Sienna

Indigo

Cadmium Orange

Yellow Ochre

Oil pastel

orange

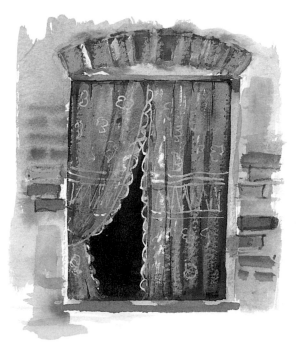

❸ Rub off the masking fluid. Apply up to three watery washes of white gouache over the curtains. Let each wash dry before applying the next. Complete the brickwork using orange, red and yellow watercolours and orange oil pastels.

Barn doorway

Another useful subject is a doorway, which, once you gain confidence, can be drawn to include people, animals, plants or garden implements in future work.

❶ Draw in the main features. With a brown watersoluble pencil, emphasize the door frame plus the start of the stonework. Apply masking fluid to the chicken wire at the top, and to the grasses at the base of the door.

burnt sienna

dark brown

Oil pastels

cream

neutral grey

❷ Loosely apply cream and grey oil pastels to the stones and door. Using burnt sienna watersoluble pencil, draw in the rusty hinge and nail heads, plus the wood grain on the door. Paint a dark grey over the top window section.

Watercolours

Neutral Grey

Cerulean

Olive Green

Payne's Grey

❸ Wash Neutral Grey watercolour across the stonework to emphasize the oil pastel work. Rub off the masking fluid, and paint blue on the door and green over the grasses.

BUILDINGS

169

Roofs

Each section of a building has its own individual style, design and materials. Look hard at the colour, texture and structure of some different roofs. It is amazing just observing their colours, and the way in which the tiles slot into and jut up to each other. Try out several versions for yourself.

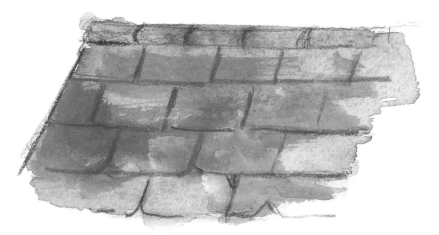

▲ This fairly ordinary grey slate tile resembles brickwork. Each tile straddles the adjacent row, with a terracotta ridge capping the top.

▶ Pantiles are fabulous tiles that interlock to form ridges and patterns that are a joy to look at, but not easy to represent! Watersoluble sepia ink outlines these tiles, and Violet and orange watercolours fill in the roof colour.

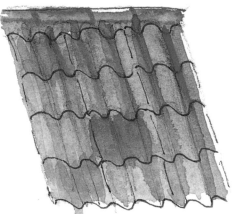

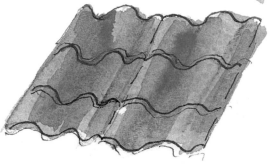

◀ One tile clips over the next, forming an interesting flowing pattern. These are drawn in watersoluble inks with orange watercolours.

Brickwork

Studying the structure and texture of the material of any subject is essential, and brickwork is a good example of this. The colours vary considerably, and weathering and ageing of the bricks makes garden walls and paths more interesting. These examples have been painted on a sandy pastel paper.

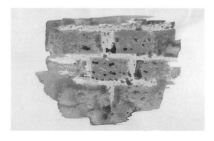

▲ Bricks and mortar are outlined in oil pastels, which act as a resist to the darker watercolours applied over the top.

▲ Soft pastels are applied to the brick shapes and the mortar, and ink details added afterwards.

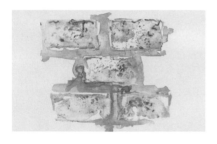

▲ Assorted watersoluble pencil shavings are splintered into the wet brick shapes to mingle. Grey watercolour mortar is added.

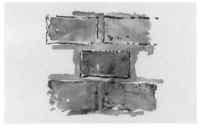

▲ Waterproof and watersoluble inks are then used for the brickwork, with grey watercolour for the mortar.

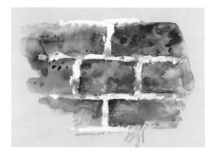

▲ Here watercolours are applied wet-into-wet for the bricks, while white gouache is used to create the mortar.

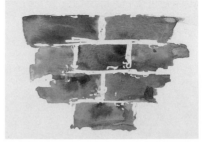

▲ Masking fluid is used for the mortar shapes, the bricks are added in watercolour then the masking fluid is rubbed off.

EXERCISE # Sketch a street in pastel pencils

If you have lots of holiday photos in a drawer, see if you can find a simple street scene to sketch like this Spanish one. Travel brochures are useful if you have no photographs. After using photos, try working from life.

The palette
Pastel pencils

red orange green mauve blue

 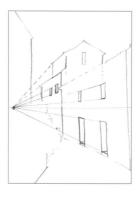 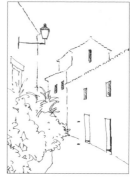

❶ In pencil, lightly draw the main outlines of the street and buildings. When you work from life, always check the shape of the sky, and also the proportions of the roof shapes.

MUST KNOW

Adding figures
Placing a figure in a scene will always add interest to your work and will help to give it scale. The shadow it casts can provide a sense of sunshine.

❷ Drop down some vertical lines for the edges of the buildings and lightly draw a horizontal line for your eye level. Extend the lines of the rooftops on the right, to meet at a vanishing point on the eye level. Now position the windows and doors, checking to see where they come in relation to points on the roof, and each other. The angles of the tops and bottoms of the windows and doors will meet at the vanishing point.

❸ Switch to a black art pen or fine point pen. Draw the buildings, using broken lines, and suggest foliage on the left with scribble marks. When the pen marks are completely dry, erase the pencil construction lines. The two small dots to the left of the central doorway are there to show the position of a figure. This is a good tip – always note where a figure's head and feet lie in relation to the surroundings.

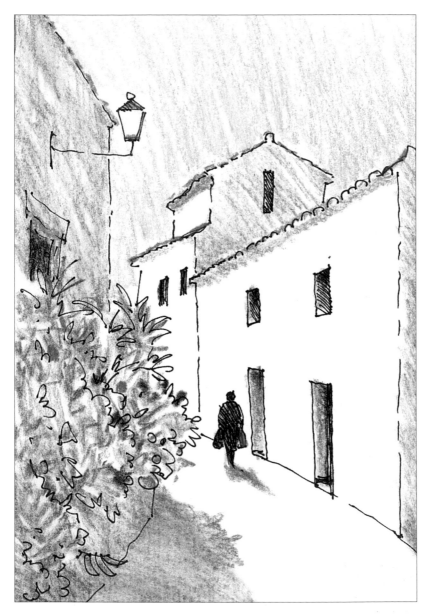

④ Quickly drop in the figure – the less you fiddle with it, the better it will be. Do not make the head too large. Using pastel pencils, work over the pen drawing, softening the colour in places with your fingers. The purple shadows will give a wonderful feeling of strong Mediterranean sunlight to your picture.

EXERCISE Sketch a church in mixed media

A traditional church will provide you with an interesting and challenging subject. You can either work from photographs or quick sketches or you may wish to take along your art materials and sketch in situ.

The palette

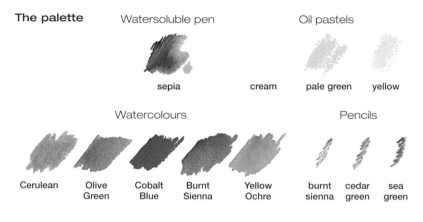

Watersoluble pen

sepia

Oil pastels

cream pale green yellow

Watercolours

Cerulean Olive Cobalt Burnt Yellow
 Green Blue Sienna Ochre

Pencils

burnt cedar sea
sienna green green

❶ Sketch in all the main details. Apply some masking fluid to the roof, tops of the tombstones, grasses, church clock and windows. Add dark areas with a sepia watersoluble pen. Apply some yellow and pale green oil pastels to the grass areas.

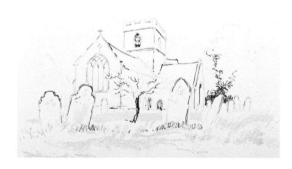

❷ Paint the sky Cerulean. Mix green and Cerulean for the trees, adding Cobalt Blue to those on the right with a little yellow at the top and in the front tombstones. Darken the windows and clock in Cobalt Blue; add brown plus yellow for the other tombstones. Paint the roof brown.

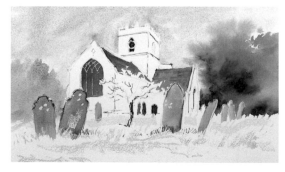

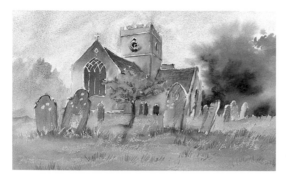

❸ When completely dry, paint in the middle distance using yellow and a touch of green. Then adding more Cerulean, paint in the foreground, then paint in the small tree details. Paint the church a mix of yellow, brown and a little Cerulean.

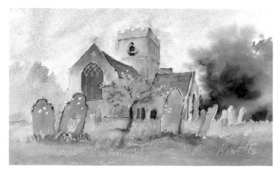

❹ When dried thoroughly, rub off the masking fluid leaving the detailed white paper. Now gently merge the light areas into the background, brushing over yellow watercolours.

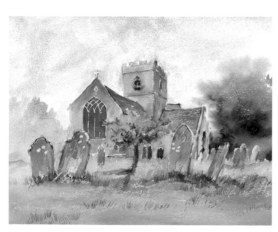

❺ Finished picture: white 300 gsm (140 lb) watercolour paper, 28 x 36 cm (11 x 14 in). Using sea green pencil, detail in the final stages of the small foreground tree. Pencil in some foreground grasses using cedar green and burnt sienna. For extra light apply the cream pastel gently over the distant tree surfaces, roof and tombstones. Re-state the undulating shadows connecting the front tombstones using Cobalt Blue with green watercolour.

want to know more?

Take it to the next level...

Go to ...

▶ **composition** – page 36
▶ **foreground & distance** – page 40
▶ **sketching skies** – page 116

Other sources

▶ **Photographs**
 useful sources of reference
▶ **Sketchbooks**
 for keeping a record of what you see
▶ **Art exhibitions**
 visit or even show your own work
▶ **Local venues**
 may allow you to display/sell your work
▶ **Publications**
 visit www.collins.co.uk for Collins art books

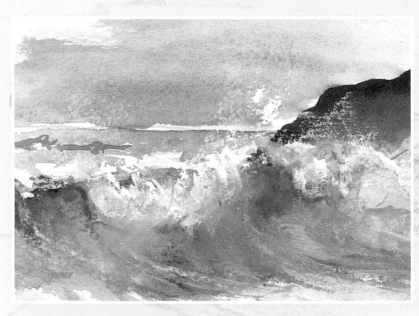

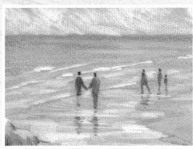

seaside

The seaside offers a richness
and abundance of subjects
for sketching. Your challenge
is to convey the large expanse
of open water, sky and beach,
with few trees or vegetation.
The movement of the waves
is quite different to inland
water subjects. There are so
many things to draw that you
could keep a sketchbook just
for seaside sketching.

Seaside sketching

The seaside is a perfect place to sketch. There are so many possible subjects – sea, shore, boats, jetties, windbreaks – the list is endless, and in the limited space of a few pages, we can only hint at the variety of fascinating possibilities.

Sea

Let's begin with the sea. Sketching waves is fun, but requires a high degree of observation and concentration. Spend at least five minutes watching the way in which a wave rises and tumbles over, and how it changes colour. When you begin to feel familiar with the pattern of movement, you can make a series of quick studies.

❶ Use horizontal strokes of bright blue watersoluble pencil for the horizon and sea, and curving strokes for the breaking wave. Block in the water behind the wave, leaving gaps for distant waves. Use a light yellow-green for the top and 'inside' of the wave, and blue for its shadow.

❷ With a wet brush, 'loosen' the colour. While the paper is wet, you can add more blue pencil if you have lifted too much colour. When the paper is dry, use a craft knife to scratch the paper to create a few bubbles on the edge of the wave, and for a few 'white caps'.

bright blue yellow-green

Rocks

Rocks on the beach will often have quite complex shapes, having been battered by the elements for ages. By squinting, you can simplify their shapes into simple blocks. Always begin with the main, large shape, and add details, such as cracks and textures, last.

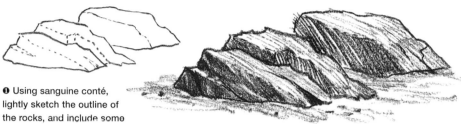

❶ Using sanguine conté, lightly sketch the outline of the rocks, and include some suggestion of their blocky shapes, using a line to show where there is a change of plane. It helps to squint, to simplify the rock's shape.

❷ If light strikes the top of the rocks, then the side planes will receive less light. Use linear strokes of conté, building up a heavier concentration of strokes on the darker sides of the rocks, and add details, such as cracks.

Boats

Boats can be tricky to draw, since they bob about on water, tilt on land, and have complicated curving shapes with strange bulges. Always check proportions properly, and study shapes carefully. Choose simple shapes first, and move on to boats with masts, rigging and other paraphernalia.

❶ Draw a simple rowing boat with a pencil, freehand. Now check the tilt of the boat. Look at the red dotted line, and see how the prow is lower than the stern.

❷ Add tonal shading for the bulge of the hull. Make the nearest edge firmer than the distant edge, to bring it forward. The darkest marks are the shadows inside the boat.

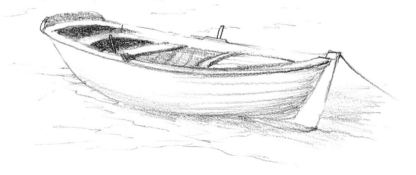

Seaweed and pebbles

Pebbles are the sea's gorgeous jewellery, and seaweed its underwater forest, a lucrative combination for the painter. When exposed at low tide both are a testament to the variety and complexity of marine life. They offer an endless source of inspiration for mixing different media.

▶ This matted growth of bladderwracks with their inflated oval fronds and bladders are a familiar sight on rocks and seashore in the summer. Olive Green, Burnt Sienna and Cobalt Blue watercolours are painted with a narrow brush to show the weeds, rocks, stones and distance. The stones in the foreground are splattered in with Sienna, and the highlights on the seaweed dotted in using cream oil pastel.

▼ This red feathered seaweed common in rockpools at low tide clings to shells and stones. Masking fluid and sepia watersoluble ink are used for the initial details. More details are then added with a waterproof sepia pen. After wetting the whole drawing with water and letting it dry, the masking fluid is rubbed off and a watercolour wash of light Yellow Ochre is painted over to unite the whole picture.

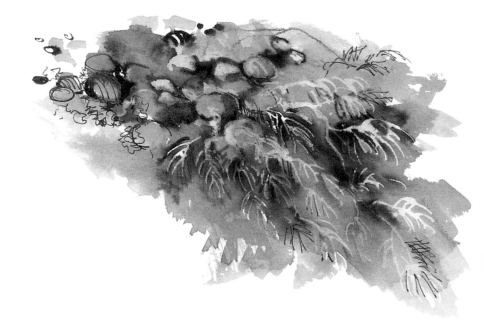

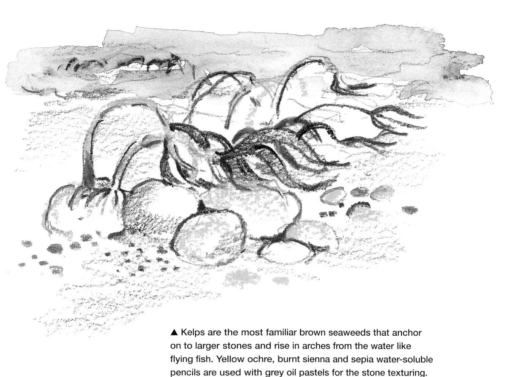

▲ Kelps are the most familiar brown seaweeds that anchor on to larger stones and rise in arches from the water like flying fish. Yellow ochre, burnt sienna and sepia water-soluble pencils are used with grey oil pastels for the stone texturing. Everything is kept dry, except the cobalt blue added from the tip of a watersoluble pencil with a brush for the distant sea.

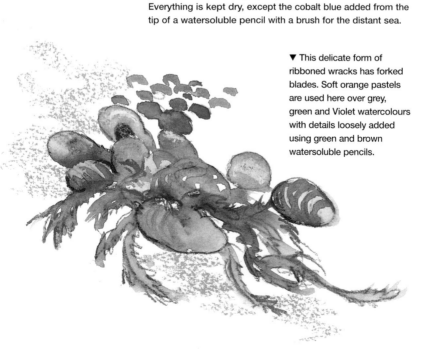

▼ This delicate form of ribboned wracks has forked blades. Soft orange pastels are used here over grey, green and Violet watercolours with details loosely added using green and brown watersoluble pencils.

EXERCISE # A beach walk in pastel pencils

Putting a few figures into a scene will immediately add a sense of scale. The figures in this sketch are just suggested, but their small size helps to emphasize the vast expanse of the ocean and the beach.

The palette

Pastel pencils Art pen

| white | orange-pink | pale yellow | raw sienna | orange | pale grey | dark grey | blue | blue |

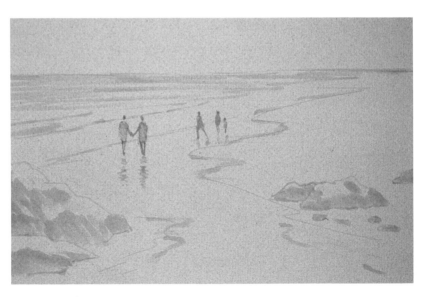

❶ On blue-grey pastel paper, draw the scene with an art pen. Use the brush tip to block in the darker sides of the rocks and add horizontal strokes for the sea. The people's heads are all in line (except the child). Try to get their proportions right.

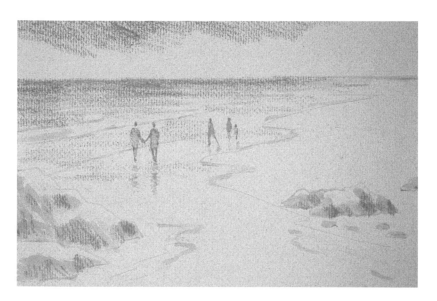

❷ Switch to pastel pencils, and scribble in some blue for the sky, and some horizontal strokes for the sea. Also, put some blue onto the darker sides of the rocks. We are going to build up the rocks with lots of different colours, to make them interesting.

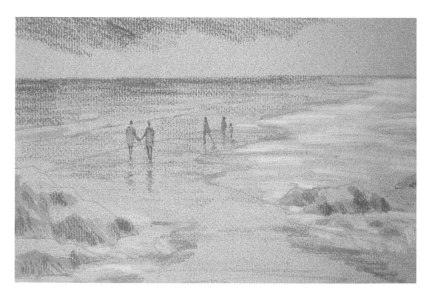

❸ Use yellow and raw sienna for the sand. Wet sand is darker than dry sand. In the fore-ground, separate your strokes a little to suggest undulations in the surface. In the distance, use sweeping horizontal strokes which blend together naturally.

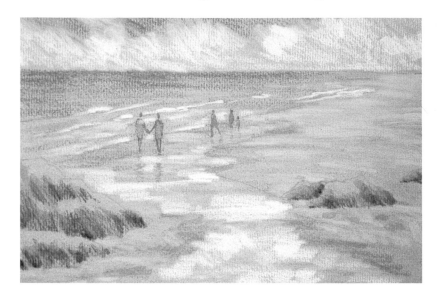

❹ Use white for the clouds, wave edges, and water on the sand, pressing hard where the clouds are reflected. Change the direction of your strokes in the clouds for a lively effect. Use dark grey and a little raw sienna on the darker sides of the rocks.

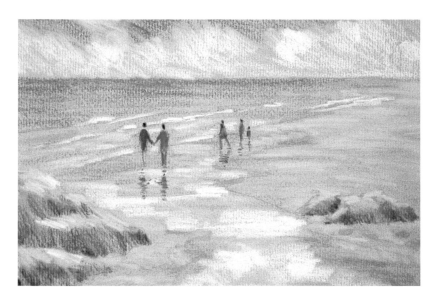

❺ Tiny strokes of colour can indicate the people's clothes, and you can use the same colours with some small horizontal, broken strokes for the reflections. Use dark grey for the heads. Work more detail into the rocks with some pale grey.

THE SEASIDE

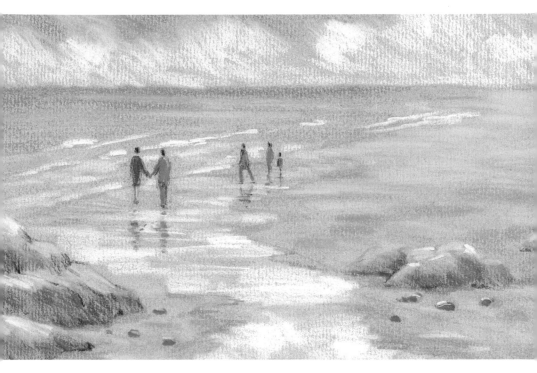

➒ Finished picture: Pastel paper, 15 x 23 cm (6 x 9 in). Add a few dark grey pebbles, with a touch of a lighter colour on the top. Stroke a little blue at the base of the rocks for the shadows. You can suggest a few cracks in the rocks with some dark grey, and add a few strokes of orange-pink to the sand. Finally, you can help to break up the people's reflections slightly just by using a few horizontal strokes.

MUST KNOW

Check the horizon

When sketching, you should always check to make sure that the horizon is, in fact, horizontal, and perfectly parallel with the top of your paper. So many beginners' drawings are spoiled by horizons that slope up or down. If you are unsure, check your horizon with a set-square.

A seascape in watercolour

A lasting memory of the seaside is the tumbling and unfurling waves. Each unravels and splashes against rocks and along the shore. This exercise tries to capture this movement and bring the sea to life.

❶ Using a 2B pencil, lightly rough in the main elements of the waves and rocks.

❷ Mix a brown with Raw Umber and a little Cerulean watercolour, and paint in the mid-distance rocks, slightly misting the edges where the top of the wave will come. Paint in the underside of the wave with Cerulean.

❸ Use Cobalt Blue for the distant stretch of sea to make a contrast with the foreground wave. Paint Neutral Grey into the sky shape, grading it so that it is darker towards the sea, and then blending it with a little Cerulean on the left.

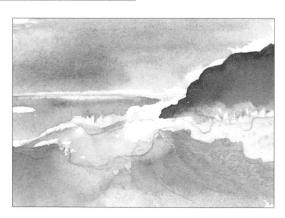

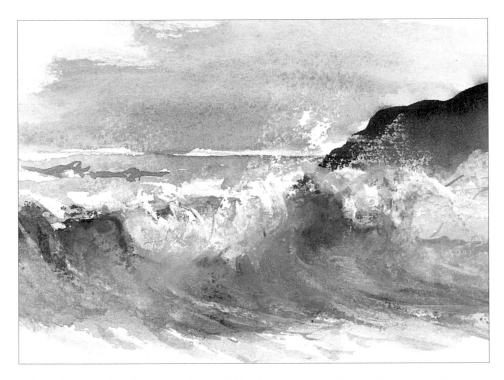

❹ Darken the underside of the waves with an additional wash of Cerulean and Cobalt Blue. When it is dry, splatter watery white gouache against the wave edges for the spray. Add small directional lines of Cobalt Blue to the foreground wave to complete the picture.

The palette
Watercolour

Cerulean	Cobalt Blue

| Neutral Grey | Raw Umber |

want to know more?

Take it to the next level...

Go to ...
▶ **watercolour techniques** – page 31
▶ **sketching water** – page 128
▶ **moving water** – page 130

Other sources
▶ **Photographs**
 useful sources of reference
▶ **Art shows**
 look out for local or national events
▶ **Internet**
 interactive CD-ROMs
▶ **Painting holidays**
 expand your horizons with other artists
▶ **Publications**
 visit www.collins.co.uk for Collins art books

Need to know more?

There is a wealth of further information which is available for artists, particularly if you have access to the internet. Listed below are just some of the organizations, magazines, art shows and societies, bookclubs and internet resources that you might find useful to help you to develop your drawing and sketching and experiment with working in other media.

Art Magazines

The Artist
Caxton House, 63/65 High Street, Tenterden, Kent TN30 6BD
tel: 01580 763673
www.theartistmagazine.co.uk

Artists & Illustrators
The Fitzpatrick Building,
188-194 York Way, London N7 9QR
tel: 020 7700 8500

International Artist
P. O. Box 4316, Braintree,
Essex CM7 4QZ
tel: 01371 811345
www.artinthemaking.com

Leisure Painter
Caxton House, 63/65 High Street, Tenterden, Kent TN30 6BD
tel: 01580 763315
www.leisurepainter.co.uk

Art Materials

Daler-Rowney Ltd
Bracknell, Berkshire RG12 8ST
tel: 01344 424621
www.daler-rowney.com

Winsor & Newton
Whitefriars Avenue, Wealdstone,
Harrow, Middlesex HA3 5RH
tel: 020 8427 4343
www.winsornewton.com

On-line Art Supplies/Mail Order
www.lawrence.co.uk
www.jacksonsart.com
Both of the above provide art materials by mail order, often at discount prices.

Art Shows

Artists & Illustrators Exhibition
The Fitzpatrick Building,
188-194 York Way, London N7 9QR
tel: 020 7700 8500
(for information and venue details)

Patchings Art, Craft & Design Festival
Patchings Art Centre, Patchings Farm,
Oxton Road, Calverton,
Nottinghamshire NG14 6NU
tel: 0115 965 3479
www.patchingsartcentre.co.uk

Battersea Affordable Art Fair, London
Twice-yearly large exhibition with over 50 galleries under one roof, showing contemporary paintings.
Also annual exhibition in Bristol, in the Spring; tel: 020 7371 8787

Art Societies

Federation of British Artists
Mall Galleries, 17 Carlton House Terrace,
London SW1Y 5BD
tel: 020 7930 6844
www.mallgalleries.org.uk

Society for All Artists (SAA)
P. O. Box 50, Newark,
Nottinghamshire NG23 5GY
tel: 01949 844050
www.saa.co.uk

Bookclubs

Artists' Choice
P. O. Box 3, Huntingdon,
Cambridgeshire PE28 0QX
tel: 01832 710201
www.artists-choice.co.uk

The Arts Guild
On-line bookclub devoted to books on
the art world
www.artsguild.co.uk

Painting for Pleasure
Brunel House, Newton Abbot,
Devon TQ12 4BR
tel: 0870 4422123

Internet Resources

Art Museum Network
The official website of the world's
leading art museums
www.amn.org

Artcourses
An easy way to find
part-time classes, workshops and
painting holidays
www.artcourses.co.uk

British Arts
Useful resource to help you to find
information about all art-related matters
www.britisharts.co.uk

British Library Net
Comprehensive A-Z resource including
24-hour virtual museum/gallery
www.britishlibrary.net/museums.html

Galleryonthenet
Provides member artists with gallery
space on the internet
www.galleryonthenet.org.uk

Painters Online
Interactive art club run by The Artist's
Publishing Company
www.painters-online.com

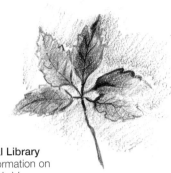

WWW Virtual Library
Extensive information on
galleries worldwide
www.comlab.ox.ac.uk/archive/other/
museums/galleries.html

WetCanvas
This is part magazine, part virtual
classroom, and part reference site. It is the
largest community site on the internet with
a specific focus on the practising visual
artist. It concentrates on providing the
following services to visitors and members:
● A virtual community where artists can
share ideas, critiques, and other
information
● Tools for managing and promoting
virtual/online galleries of work
● A complete array of art lessons and
tutorials for all levels of artists
● Product comparison and research
information for art supplies and services
● An image library
www.wetcanvas.com

Jackie Simmonds
The website of one of the authors of this
book, providing a gallery of images, a tips
and hints page, and information about the
artist's workshops, painting holidays, books
and videos.
www.jackiesimmonds.co.uk

Videos

APV Films
6 Alexandra Square, Chipping Norton,
Oxfordshire OX7 5HL
tel: 01608 641798
www.apvfilms.com

Teaching Art
P. O. Box 50, Newark,
Nottinghamshire NG23 5GY
tel: 01949 844050
www.teachingart.com

Index

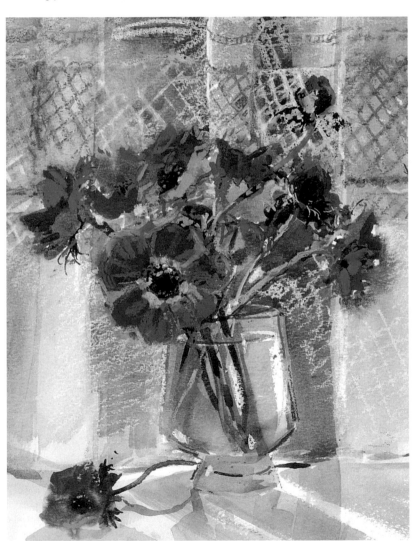

⟨ Collins need to know?

Look out for these recent titles in Collins' practical and accessible need to know? series.

Other titles in the series:

To order any of these titles, please telephone **0870 787 1732** quoting reference **263H**.
For further information about all Collins books, visit our website:
www.collins.co.uk